IN FOCUS

Edited by Klassik Stiftung Weimar

T0337690

KLASSIK
STIFTUNG
WEIMAR

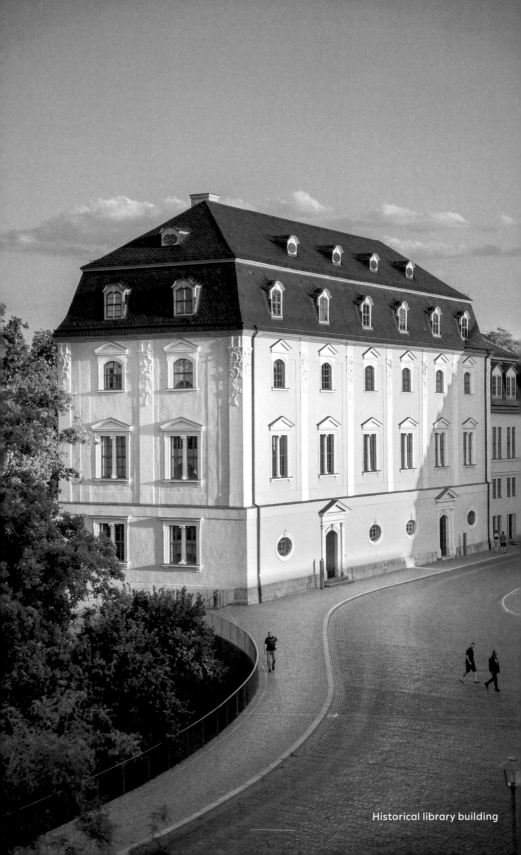

Historical library building

DUCHESS ANNA AMALIA LIBRARY

Edited by Reinhard Laube

With contributions from
Arno Barnert, Annett Carius-Kiehne, Andreas Christoph,
Alexandra Hack, Rüdiger Haufe, Stefan Höppner, Reinhard Laube,
Katja Lorenz, Christian Märkl, Christoph Schmälzle,
Veronika Spinner, Claudia Streim, Ulrike Trenkmann, Jürgen Weber
and Erdmann von Wilamowitz-Moellendorff

Deutscher
Kunstverlag

KLASSIK
STIFTUNG
WEIMAR

TABLE OF CONTENTS

FOREWORD

With a history going back more than 300 years, the Herzogin Anna Amalia Bibliothek (Duchess Anna Amalia Library) is steeped in tradition as is almost no other cultural institution in Weimar. It was given the name it bears today only in 1991 in honour of the duchess who had the famous Rokokosaal (Rococo Hall) built and whose passion for European arts and letters was to shape the library's collections with enduring effect. The name also serves as a pointer to the library's focus on the period around 1800 and its key mission as an archive and scholarly resource for that era. In addition to the Renaissance castle that has housed the library since the eighteenth century, its premises now include a modern Study Centre that opened in 2005. This building is located on the opposite side of the Platz der Demokratie, a public square that re-calls momentous historical events such as the Revolution of 1918, the adoption of the constitution of the Weimar Republic and the "peaceful revolution" of 1989. Installed underneath this square are the library's new stacks and an underground passageway that bridges the divide between the old ducal library and the modern library complex. The fire of 2004 severely damaged the historical building, which had to be painstakingly repaired and restored. Re-turned to its former glory, it reopened in 2007 and, together with the stacks and the new Study Centre, now forms a library campus. That the library was able to rise from the ashes at all was thanks to the tremendous grassroots support that it enjoys. Amongst the innovative developments that will safeguard the collections for future generations are new techniques for paper restoration and a digital semantic net that will record the findings of the research being done into the provenance and circumstances of the library's

acquisitions. The library is also working non-stop on the digitalisation of its spaces and objects and on new scenarios for the use of its buildings.

Just as the Study Centre broadened the scope of the historical building in a modernist direction, so in 2022 there is to be another act of symbolic bridge-building, but this time back to the early modern age when the first of the Weimar collections was being amassed. The Renaissancesaal (Renaissance Hall) on the ground floor of the historical library building is to open with an exhibition on Lukas Cranach and the Reformation. The rooms preceding the Rokokosaal on the first floor and inside the Bücherturm (Book Tower) – accessed via the Herzogsteg (Duke's Walkway) – will also be used as presentation spaces. The ground floor entrance area thus invites visitors to discover these earlier periods and to step, as it were, from one epoch into the next. Meanwhile, the Study Centre has set itself the task of addressing both today's media revolution and the multifarious interests of its readers and guests. It is also working on creating spaces that foster research, dialogue and education, such as the Galerie der Sammlungen (Gallery of the Collections), reading lounge and makerspace for digital applications.

The history of the library as an institution began with the ducal book collection, which from 1547 onwards was housed in the duke's new castle in Weimar. Its transfer to the Renaissance-style 'Grünes Schloss' (Green Castle) in 1766 brought it a certain degree of autonomy, ushering in a period of growth that is closely tied to Duchess Anna Amalia. It was she who prompted the installation of a multistorey library hall to accommodate the book collection inside the Grünes Schloss, and it was she who placed Goethe in charge of the library in 1797. During his term of office, which ended only at his death in 1832, the management of the collection and running of the library were placed on a more professional footing, as evidenced by the issuance of new rules governing its use, the proper documentation and cataloguing of its holdings and an acquisitions policy.

The library is part of Weimar's social history, and this is reflected in the history of its collections and interiors: in the early nineteenth-century expansion of the Militärbibliothek (Military

Library), in the library's reinvention of itself as a regional public library during the Weimar Republic, in its misappropriation of looted books under the Nazis and later in its role as the library of the Nationale Forschungs- und Gedenkstätten der klassischen deutschen Literatur (National Research and Memorial Sites of Classical German Literature), one of East Germany's leading research institutions. A new phase began in 1991 with the decision to make it a major research library called the Herzogin Anna Amalia Bibliothek. In this latest incarnation, it has indeed matured into a cultural institution whose centuries-old collections and timeless holdings invite us to ponder both present and future. The library's opening of doors has made it a cultural authority and hence also a place for reflection.

One such door is this latest volume in the Klassik Stiftung Weimar's 'In Focus' series, which, besides offering an introduction to the library and a tour of its collections, opens up new perspectives for readers and guests alike. While weighty publications on the history of the library and bibliographies of its collections already exist, the purpose of this book was to present a selection of key objects that would shed light on the institution, the buildings it occupies and its collections, while also addressing its current interests and issues. Manuscripts, early prints and pamphlets, and niche collections such as the horticultural library, the sheet music collection and an assortment of maps and globes lend the Herzogin Anna Amalia Bibliothek its distinctive profile. Also noteworthy are the paintings and busts in the Rokokosaal that have imprinted themselves onto that central space, the interior of which is a reconstruction of the hall as it was in 1850. The libraries of Goethe and Nietzsche are each represented by one key object and presented as important collections in their own right. While it was only to be expected that Weimar would have its own Faust collection, research into the provenance of these books has brought to light some unexpected facts relating to the history of their acquisition. Another focus is literature written purely for entertainment, which used to be a blind spot here in Weimar and was for a long time eclipsed by the classics. That in 1825 the Weimar dukes' Militärbibliothek (Military Library) was accorded a special room of its

own inside the Bücherturm (Book Tower) close to the Rokokosaal is hardly surprising, given the vital role played by armies and warfare during the Age of Revolutions. What is surprising is that the connection between the history of this collection and the space it occupies so often goes unremarked. The underground literature of East Germany, a collection which, notwithstanding its relevance to local issues, could be amassed only *ex post*, also references an important period in the history of the institution. Another collection, sadly, is that of the charred books retrieved from the debris of the fire of 2004 that have since been restored. The volume ends with a brief history of the collection and suggestions for further reading, confirming that its aim was only ever to home in on certain highlights and provide pointers to others.

The texts were authored by the library staff assisted by Christoph Schmälzle (on the art of the Rokokosaal) and Andreas Christoph (on the terrestrial globe by Johannes Schöner). They were carefully edited by Angela Jahn, while Veronika Spinner brought great circumspection and professionalism to bear on the task of ensuring the overall coherence of the volume. The steady stream of ideas, critique and corrections from the library's editorial team with Arno Barnert, Hannes Bertram, Andreas Schlüter, Veronika Spinner, Claudia Streim and Jürgen Weber did much to advance the project. Sincerest thanks are due to all those involved.

May this work spark its readers' curiosity about the Herzogin Anna Amalia Bibliothek and inspire them to visit it.

Reinhard Laube

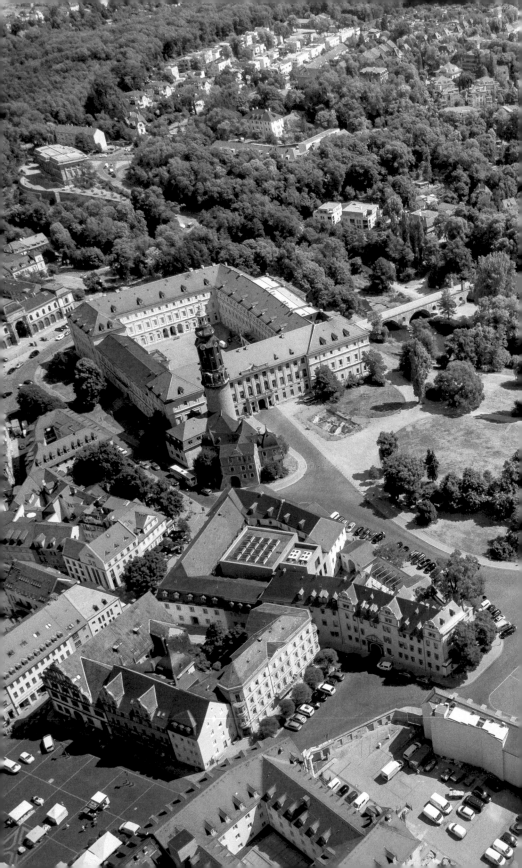

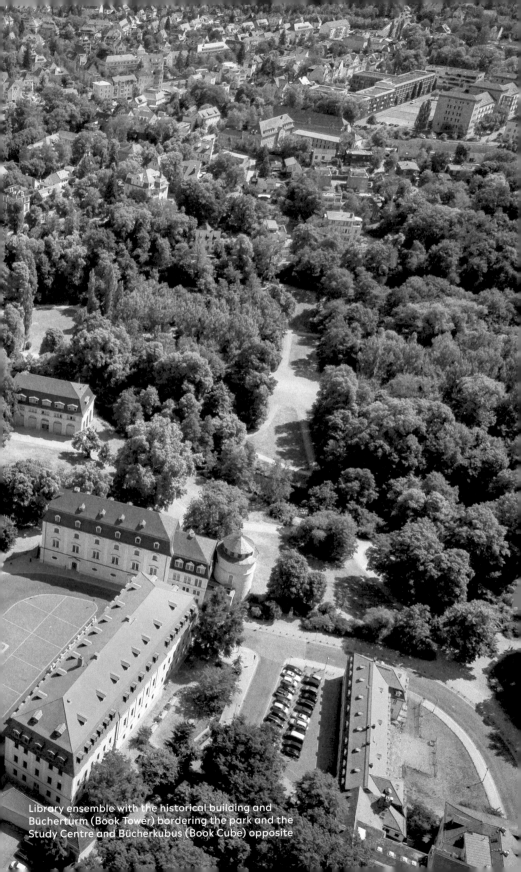
Library ensemble with the historical building and Bücherturm (Book Tower) bordering the park and the Study Centre and Bücherkubus (Book Cube) opposite

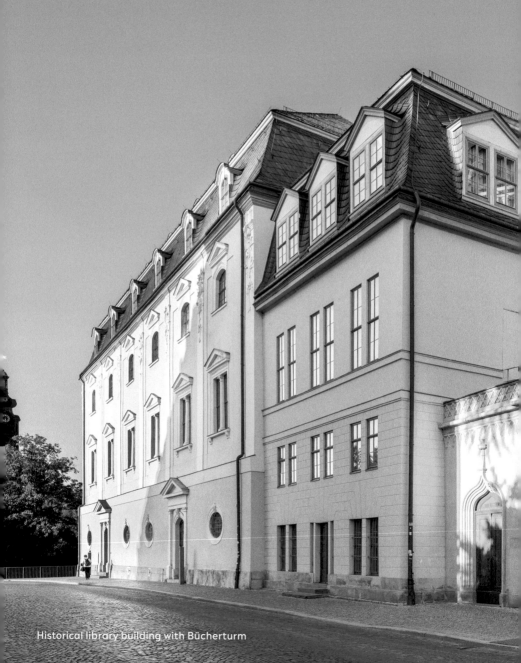
Historical library building with Bücherturm

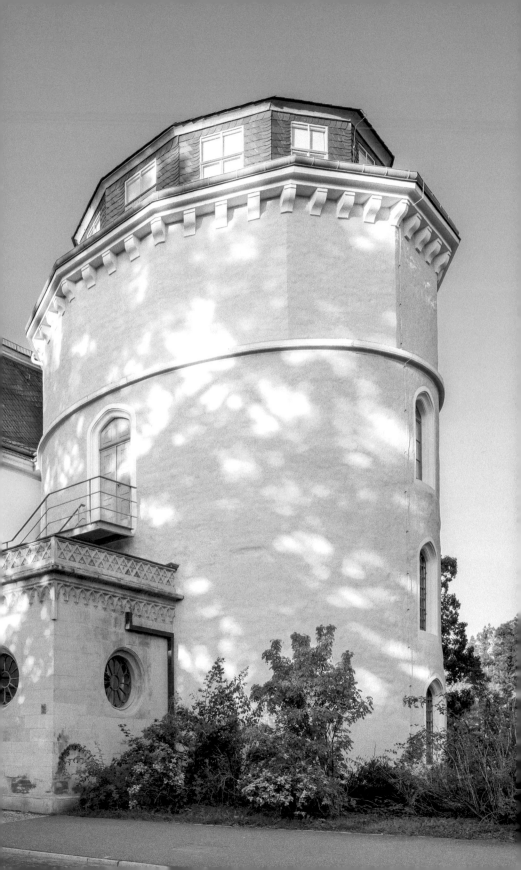

Historical library building from the park

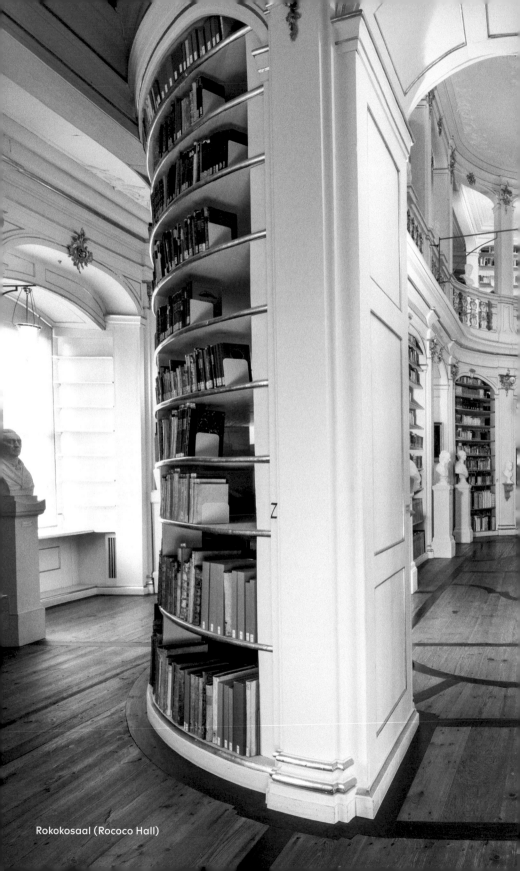

Rokokosaal (Rococo Hall)

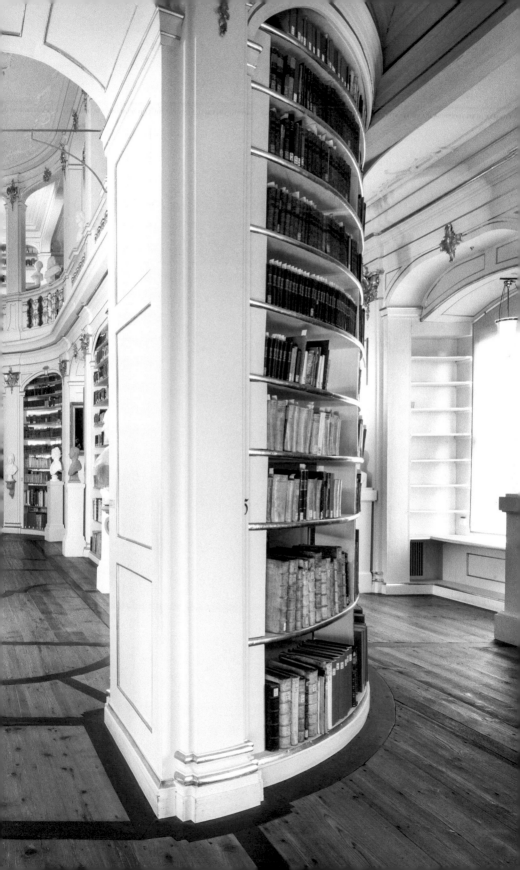

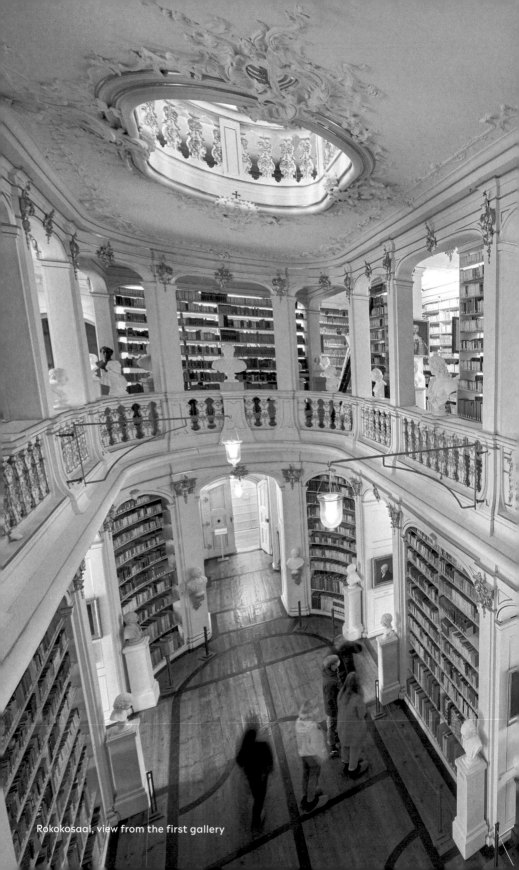

Rokokosaal, view from the first gallery

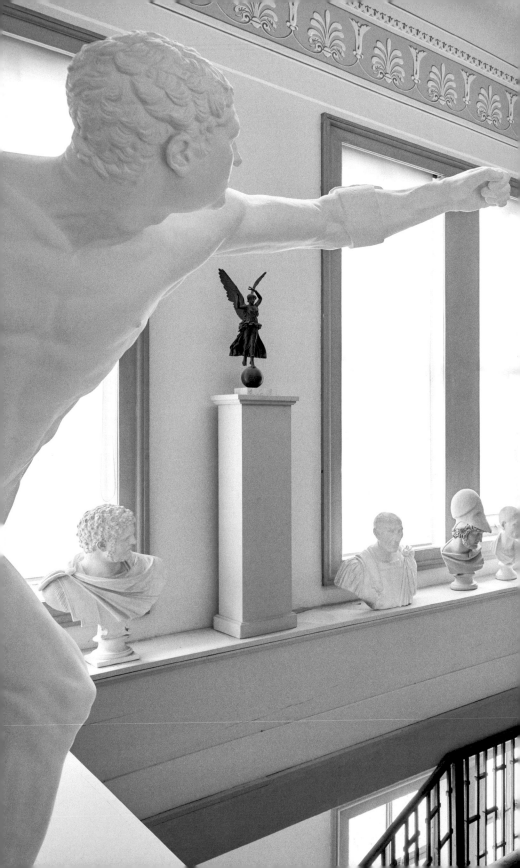

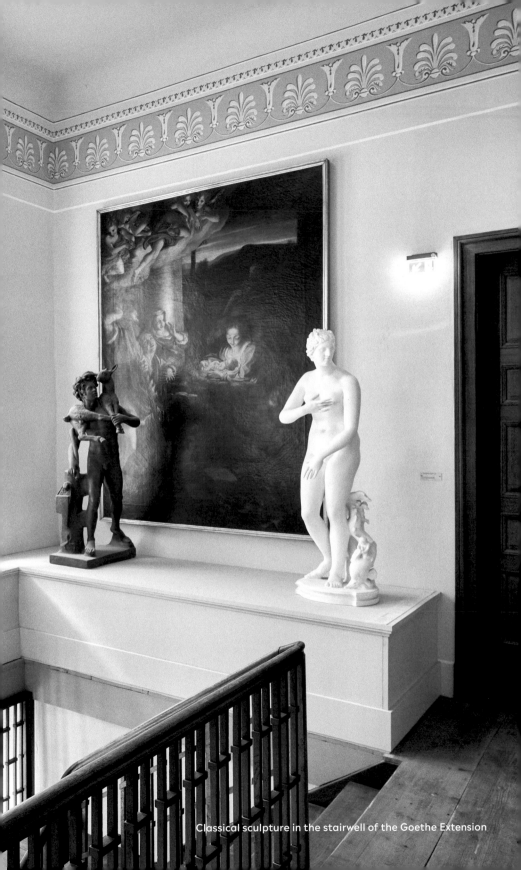

Classical sculpture in the stairwell of the Goethe Extension

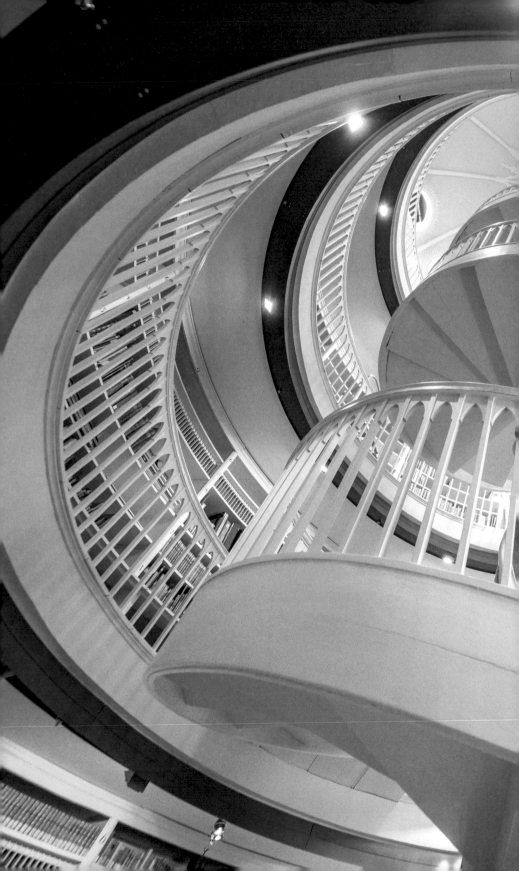

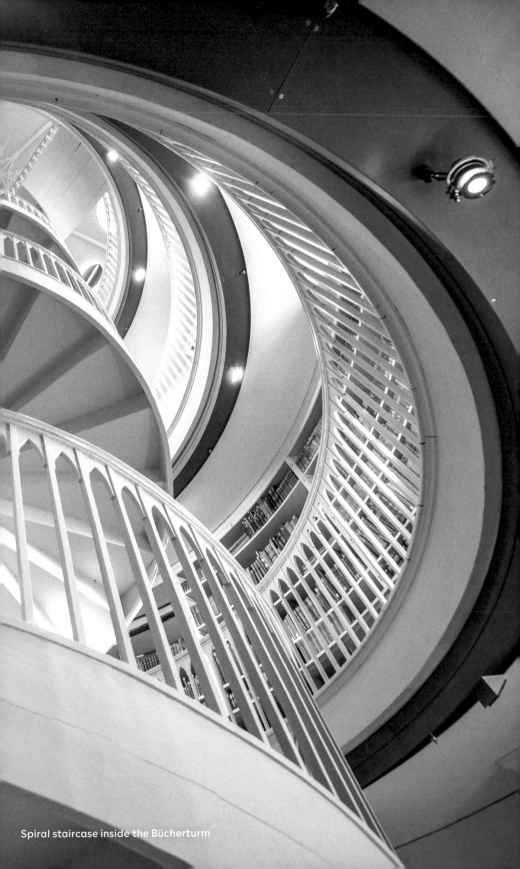

Spiral staircase inside the Bücherturm

HERZOGIN ANNA AMALIA BIBLIOTHEK – BEGINNINGS, SPACES AND KNOWLEDGE

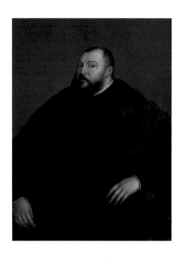

Fig. 1 | Johann Peter Krafft, Johann Friedrich the Magnanimous, Elector of Saxony, copy after Titian, 1815, KSW, Museen, inv. no. KGe/01346

The story of the Herzogin Anna Amalia Bibliothek (Duchess Anna Amalia Library) begins with a defeat. Johann Friedrich, Elector of Saxony and leader of the Protestant Schmalkaldic League, lost the decisive Battle of Mühlberg an der Elbe in 1547 to the forces of Emperor Charles V. Not only was he immediately stripped of his status as an elector, but he had to forfeit much of his sovereign territory, including the ducal seats of Torgau and Wittenberg; and, for the next five years, he was a prisoner of the emperor (fig. 1). The history of the ducal book collections and of the institution of a library bearing the sovereigns' names and housed in their castles is thus closely tied to the development of Weimar as the Ernestine dukes' new residence. Its central locations were the Residenzschloss (Ducal Castle) and Grünes Schloss (Green Castle), the latter being the historical building that houses today's library and that is famous for its magnificent interiors, including the Renaissancesaal (Renaissance Hall) and Rokokosaal (Rococo Hall), and the Bücherturm (Book Tower) later built onto it. The Studienzentrum (Study Centre) with its new Bücherkubus (Book Cube) and stacks installed underneath the Platz der Demokratie have been part of the library ensemble since 2005. The library was given the name Herzogin Anna Amalia Bibliothek in 1991. An archive and research library, its focus is on the history of European literature and culture in the period from 1750 to 1850. This area of specialisation grew out of the history of the collection and as a guiding principle will inform the future devel-

opment of the library itself, its activities, buildings and facilities. The collections are constantly being enlarged, gaps closed and the losses suffered in the fire of 2004 replaced. The focus is not only on the Age of Revolutions around 1800, but also on the Reformation upheavals of the sixteenth century, and Weimar modernism from 1900 to the present. The library remains committed to its collecting traditions, which in their turn have themselves become a subject of scholarly inquiry. Key individuals and subjects specific to the history of Weimar also have a place in the collection, as do new media, world literature and related scholarship, and with it the vast field of literature in translation.

Origins 1547

The Capitulation of Wittenberg of 1547 awarded the books belonging to the famous Wittenberger Bibliothek (Wittenberg Library) to Johann Friedrich, Elector of Saxony, who has been hailed as a champion and defender of Protestantism ever since the sixteenth century. Most of the books were initially deposited in Weimar, but later transferred to Jena. Writing to his sons in Weimar from his prison cell, the duke exhorted them to cherish the library as a great treasure and to prevent its loss or dispersal. All that remained at the castle in Weimar was the duke's private collection, which was kept in a special book cabinet. Johann Friedrich con-

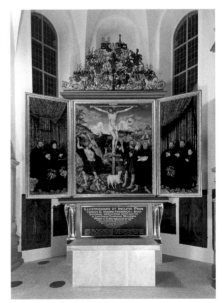

Fig. 2 | Cranach altarpiece in the church of St Peter and Paul in Weimar

tinued sending books to Weimar from his prison cell in Augsburg, and in 1549 he commissioned an inventory that eventually ran to 426 volumes. Books, in other words, were a matter of course at the new residence in Weimar, to which the former elector would return in 1552.

The new burial vault for the duke, who had returned from captivity, and his wife Sibylle installed in the choir of the church of St Peter and Paul in Weimar became a new dynastic site. The duke's three sons commissioned the Cranach workshop with a major altarpiece for it (fig. 2), which, with

its emphasis on the 'book' as a medium, looks ahead to the importance that the ducal library would later have. The theme of the painting of 1555 is the Christian notion of man's salvation by the grace of God alone, as symbolised by Christ's sacrificial death on the cross presented simultaneously with the resurrected Saviour. Also depicted, however, is the duke himself and his family along with visual attestations of their ducal pedigree and legitimacy as rulers. This staged interaction of the living and the dead also includes both Lucas Cranach the Elder, as painter to the court, and Martin Luther, who lends expression to his patron's Protestant confession by pointing to a passage from his German translation of the Bible (fig. 3).

The printed book tells of the role played by books and the written word generally in the social practice of *memoria*, that is to say, the invoking of the living and the dead in divine worship. The inscription on the predella of the altarpiece of 1555 affirms Johann Friedrich's electoral status by virtue of his birth, the ducal couple's titles and their fight for the 'right' faith, as evidenced by the scar on the face of the battle-hardened duke. The theme is the

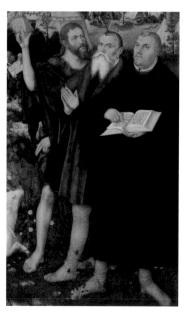

visual and written remembrance that legitimises sovereignty. The motto of the Ernestine line, VDMIAE (*Verbum Domini manet in aeternum* – the word of the Lord endureth forever), is woven into the hem of the curtain draped above the pair and serves to advertise 'the word' as a medium of communication – both the spoken word of the Annunciation and the books and hymns that were part of the Protestant liturgy, which a special library room installed in the northern side aisle of the church housed. The memorial function of the ducal vault, in other words, was tied to the organisation and exercise of ducal power, which entailed not only the development of the castle and gardens and the promotion of architecture, art and music, but also the creation of book collections and an archive as a record for posterity.

Fig. 3 | Martin Luther holding a Bible, detail of the Weimar Cranach altarpiece

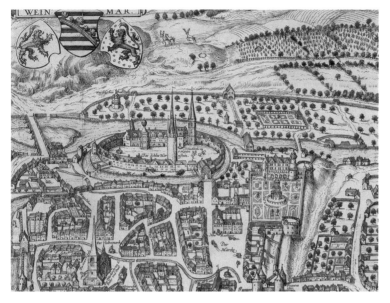

Fig. 4 | Schloss Hornstein and the 'Grünes Schloss' with garden adjoining it, detail from Johannes Wolf's map of Weimar, 2nd half of the 16th cent., KSW, Museen, inv. no. KGr-1980/00544

The Book Collections in the Residenzschloss: The Emergence of an Institution

The history of the distribution, growth and consolidation of the book collections kept in various locations begins with the death of the former elector, Johann Friedrich the Magnanimous, in 1554. Books were among the movables that changed hands as a result of inheritance and the division of domains; they also served to furnish the new living quarters at the ducal castle in Weimar. In the sixteenth and seventeenth centuries, therefore, the books belonging to the ducal family were kept not just centrally at Schloss Hornstein, but also at the Grünes Schloss built in 1562–65 and at the Rotes Schloss (Red Castle) erected opposite it in 1574–76 as the seat of the dowager duchess (fig. 4). These migrations can be reconstructed from the inventories drawn up on various occasions, whenever it was deemed necessary to take stock. The first such occasion was the fire at the Residenzschloss on 2 August 1618, which destroyed most of the collection kept there. Once the Thirty Years' War had ended, Wilhelm IV, Duke of Saxe-Weimar, pushed to have the castle rebuilt, and work on the new building commenced in 1651 (fig. 5). Called Schloss Wilhelmsburg, this

Fig. 5 | Christian Richter, Wilhelm IV, Duke of Saxe-Weimar, 1625, KSW, Museen, inv. no. G 1652

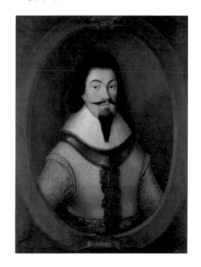

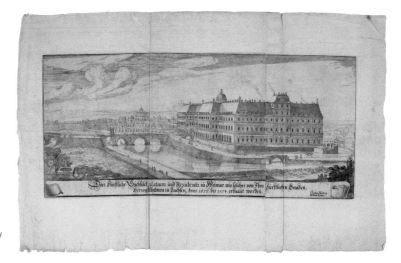

Fig. 6 | Weimar residence, 1654, KSW, Museen, inv. no. KGr-1980/00505

new residence was conceived as a dynastic seat and had its own ducal vault inside the castle chapel, called the Himmelsburg (fig. 6). The library was also promoted, not least by the Fruchtbringende Gesellschaft, one of the most important philological societies in the realm, which had been founded in Weimar in 1617 and from 1651 was headed by Duke Wilhelm IV himself (fig. 7). The renowned author and composer Georg Neumark was also recruited as a member of the society and from 1662 held the office of librarian.

The books had still been in the hands of the ducal brothers even as late as 1633. The division of the Ernestine domains of 1640, moreover, had prompted Duke Ernst I of Saxe-Gotha to transfer his own library to his new castle in Gotha, having previously kept it in the Grünes Schloss where it had been professionally maintained and had grown steadily thanks to the addition of war loot. Wilhelm IV for his part saw his own library's potential as a worthy addition to his Weimar castle – alongside the collection of books in the Kunstkammer and the extensive music collection. While his sons continued to associate the library with their deceased father following his death in 1662, that did not prevent them from dividing it up between them. The new duke, Johann Ernst II of Saxe-Weimar, did not appoint a librarian and there is evidence that he sold some of the valuable manuscripts to Gotha.

Fig. 7 | Coat of arms of the Fruchtbringende Gesellschaft, 1st half of the 17th cent., KSW, Museen, inv. no. KGe/00708

He was succeeded by Wilhelm Ernst, who continued to promote the Weimar court, including by hiring Johann Sebastian Bach. It was also Wilhelm Ernst who smoothed the way for the institution of the library, which together with the archive provided the dynasty with a historiographic arsenal as well as burnishing its scholarly credentials, ensuring that Weimar stayed ahead of the other ducal courts in the cultural rankings. A windfall of books inherited by Wilhelm Ernst in 1691 so enlarged the collection at Schloss Wilhelmsburg that even contemporaries saw in it the beginnings of a major library, to which still more collections of note would soon

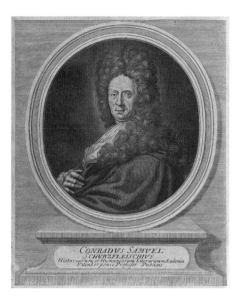

be added: that of Moritz von Lilienheim, councillor to the court of Saxe-Weimar (1701), that of the Breslau jurist Balthasar Friedrich von Logau (1704), and, finally, that of the Wittenberg scholar Konrad Samuel Schurzfleisch (1722). Schurzfleisch was also the library's first director, Duke Wilhelm Ernst having appointed him in 1706 both to enhance the library's reputation and to bring glory to its founder in the world of scholarship even long after his death (fig. 8). After Konrad Samuel's death in 1708, his brother, Heinrich Leonhard Schurzfleisch, took on the task of publishing a report on the library and its important holdings and it was his *Notitia* of 1712 that announced the opening of the Herzogliche Bibliothek (Ducal Library) to the republic of scholars. The same work also describes the rooms occupied by the library and the portraits hanging there as if by way of protection against an Alexandrine fire. Zedler's *Universallexikon* of 1738 extols 'Weymar' with a description of Schloss Wilhelmsburg and the Herzogliche Bibliothek, which is 'open for general use twice a week'. Its characterisation of the collection, however, relies heavily on a work by the librarian Johann Matthias Gesner, published in honour of Wilhelm Ernst's birthday in 1723. Hence its mention of a 'Münzkabinett' (coin cabinet), a 'Kunst- und

Fig. 8 | Konrad Samuel Schurzfleisch on the frontispiece in his *Disputationes historicae civiles* (1699), call number 19 A 8530

Naturalienkammer (cabinet of art and curiosities), and a 'Bilder-und Gemählde-Gallerie' (gallery of pictures and paintings), which are praised in the same breath as the library as proof of how the ducal seat has been upgraded under Wilhelm IV's successors. Housed in a very grand suite of rooms inside the castle, the library comprising an astonishing 18,000 volumes was one of its great attractions alongside the aforementioned cabinet of curiosities.

The Library: Buildings, Rooms and Names since 1750
The modern history of the library begins in 1750. The 1706 appointment of the librarian Konrad Samuel Schurzfleisch, who had ties to scholars all over Europe, was intended to raise the library's standing in the *res publica literaria*, while that of the brothers Wilhelm Ernst and Johann Christian Bartholomäi in 1750 was to lay the groundwork for a modern library, which was also the purpose behind the instructions issued by the then-regent concerning its opening hours, lending practices and bookbinding work, as well as the recataloguing of the books both alphabetically and by subject and their protection against dust and light. The aim now was to replace the catalogues of the various collections with a single, integrated catalogue covering the contents of the whole library. The efforts of Johann Matthias Gesner, the librarian from 1724 to 1729, were thus to be continued, the lamentable disarray rectified and the steady growth of the collection guaranteed by means of an acquisitions budget.

A floor plan of the Residenzschloss dating from 1750 shows the location of the library on the first floor of the west wing, where there were three rooms, each housing a separate library: Schurzfleisch, Logau and the 'Churfürstl. Bibliothec.', the latter being not just the name by which the ducal collection was formerly known, but also a reference to the electoral tradition of the Ernestines (fig. 9). When, in

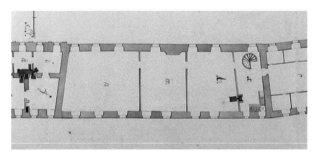

Fig. 9 | The library rooms, detail of Johann David Weidner's floor plan of Schloss Wilhelmsburg, 1750, Staatsarchiv Coburg

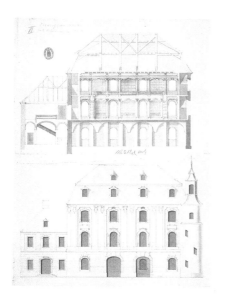

1760, Duchess Anna Amalia expressed her wish to use the three rooms housing the library for a different purpose, it was clear that an alternative plan for the library would have to be found. Fortunately, its designated new home inside the Grünes Schloss not only lent it a new guise, but also opened up scope for further development. It was here that the master-builders Johann Georg Schmid and August Friedrich Straßburger pulled off the feat of remodelling the castle interior to create the three-storey-high Rokokosaal that was completed in 1766 (figs. 10 and 11). The mathematician Achim Ilchmann recently rediscovered 'the Rokoko of the Rokokohall' and described the dynamic impression of space and light conveyed both by the hall itself and the ornaments that it contains.

In a biographical review of the work of the librarian Johann Christian Bartholomäi written in 1778, Christian Wilhelm Schneider hailed the duchess' decision to house the library in a dedicated building and the fortuitous circumstance that this had saved it from the ravages of the fire of 6 May 1774, which destroyed large parts of Schloss Wilhelmsburg. The involvement of the librarian himself in the remodelling of the Grünes Schloss is also mentioned. We learn, therefore, that it was at his suggestion that the library became 'a single large hall with three storeys, each with its own spacious gallery'. The transfer of the books to 'this fine new Temple of the Muses' was accomplished in the span of just three months in 1766. The library by now comprised some 30,000 volumes, the

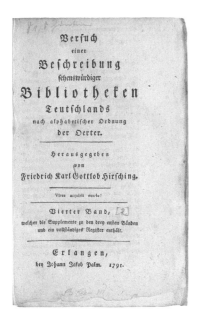

Fig. 12 | Friedrich Karl Gottlob Hirsching, *Versuch einer Beschreibung sehenswürdiger Bibliotheken Teutschlands*, vol. 4 (Erlangen, 1791), shelf mark L 7 : 35 (7)

organisation of which into three separate collections was retained. A traveller who visited the library in 1791 described it as a 'large, elongated hall with an oval in the middle and two storeys with a most convenient staircase leading to them' (fig. 12).

The institution of the library and of the ordering of knowledge that it provided took place against the backdrop of the two great European crises of the years 1755 and 1789. The first of these was sparked by the Lisbon Earthquake, which on All Saints' Day 1755 laid waste to much of that city and with it to the belief in divine providence. Then came the French Revolution of 1789 and the ensuing Napoleonic Wars, which radically reset the political compass even in Weimar. The design of the new Rokokosaal and its frame of reference are thus ambivalent. The oval clearly recalls the Great Hall of Schloss Wilhelmsburg – the same suite of rooms as once housed the library – that went up in flames in 1774 and that Zedler's *Universallexikon* had previously singled out for praise: 'The Great Hall in the shape of an oval is likewise beautiful' (fig. 13). It, too, had been surrounded by a gallery and through an oval opening in the ceiling had enabled visitors to glimpse the domed room rising up above it. Like that Great Hall, the Rokokosaal, too, was furnished with ancestral portraits and dynastic history paintings, making it more akin to a banqueting hall than a reading room. While the library in Schloss Wilhelmsburg had been part of a quasi-religious order, as symbolised by the ducal vault inside the chapel, the new library premises inside the Grünes Schloss look ahead to a new institutional order and future, even while acknowledging the library's place of origin with the monograms of Anna Amalia and her sons worked into the stucco of the oculus. The shelving might have been chaotic, as

Fig. 13 | Banqueting hall, detail from Johann David Weidner's ground plan of Wilhelmsburg (1750), Staatsarchiv Coburg

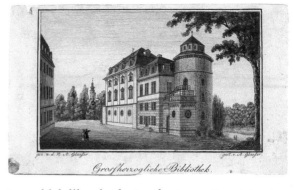

is evident from the many different bindings, formats and shelf marks, but the architecture itself engendered a certain order, its lines of sight revealing a whole cosmos of knowledge to all who entered.

And now there were catalogues, too, which likewise lent order to the knowledge stored there, both alphabetically and by subject.

The modernisation of the library continued under Johann Wolfgang Goethe, who was placed in charge of it in 1797. Besides endowing it with a new administration and new rules governing its use, he also framed a systematic acquisitions policy, which by 1832 had resulted in a collection of some 80,000 volumes. The great Weimar Classicists, writers such as Christoph Martin Wieland, Goethe, Johann Gottfried Herder, and Friedrich Schiller, were by now using it as both reading room and lending library. Goethe and his employer, Duke Carl August, also initiated architectural alterations that have shaped the building to this day: one was an extension that was built onto the south side of the building in 1805 to provide not only a new entrance but also a connection to the nearby Stadtturm (now the Bücherturm), a medieval tower that would later be used to store books (fig. 14).

Since 1805, visitors to the Rokokosaal have been greeted on entering by a large portrait of Duke Carl August in front of the Roman House in Weimar (fig. 15). This new focal point and the

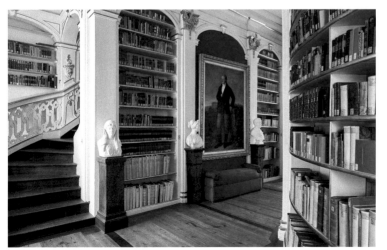

iconographic programme of busts and paintings that it ushers in would henceforth be responsible for the classical look of the interior – which incidentally would be matched by the Great Hall of Grand Ducal Castle built to replace the old one. And just as the former Great Hall had inspired the oval shape of the Rokokosaal, so the new one

Fig. 16 | Reading room in what is now the foyer, 1937

would prompt a remodelling of the main hall of the library. As the library's stock of books grew, so additional shelf space was needed to house them as well as additional rooms for consulting them. While the Rokokosaal could indeed be used more efficiently, it was clear that the space required would first have to be built. A north wing designed by Clemens Wenzeslaus Coudray that blends in perfectly with the existing façade was therefore added in 1849 and has been the main point of access to the Rokokosaal ever since.

After the end of the First World War, the Grossherzogliche Bibliothek (Grand Ducal Library) became a Thüringische Landesbibliothek (Thuringian State Library), which in 1936 was furnished with a modern reading room (fig. 16). As one of the cultural institutions that was favoured by the Nazis, it also profited from their state-sanctioned looting; in fact, confiscated works were still being added to its collections even after the end of the Second World War. In 1969, the Thüringische Landesbibliothek was merged with the library of the Nationale Forschungs- und Gedenkstätten der klassischen deutschen Literatur (National Research and Memorial Sites of Classical German Literature, NFG), an East German cultural heritage organisation founded in Weimar in 1953 and the precursor of today's Klassik Stiftung Weimar. It also took on a new name at the same time: Zentralbibliothek der deutschen Klassik. To mark its tricentennial in 1991, however, that earlier name was dropped and that of its greatest patroness, Duchess Anna Amalia, chosen instead (fig. 17).

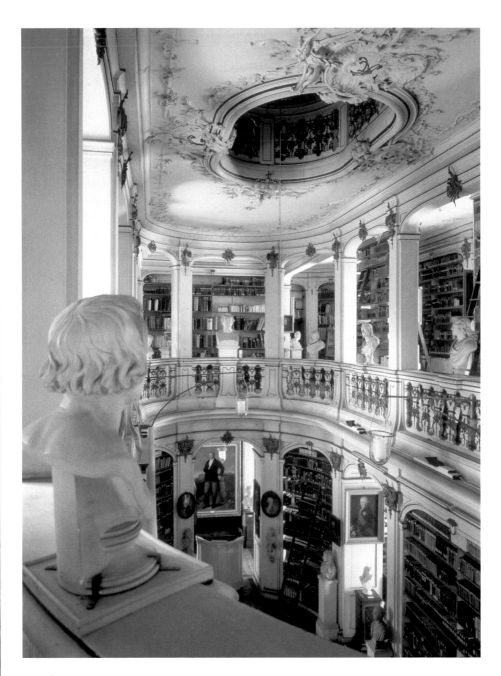

Fig. 17 | The Rokokosaal before the fire

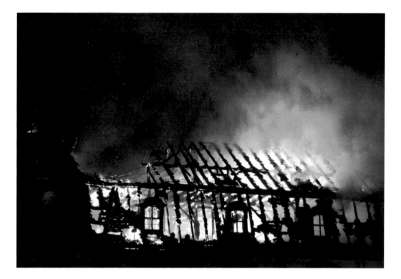

Fig. 18 | Herzogin Anna Amalia Bibliothek on the night of the fire, 2 September 2004

A devastating fire on 2 September 2004 laid large parts of the library to waste (fig. 18). Some 118,000 books damaged either by the fire itself or the water used to extinguish it were salvaged from the debris. The restoration of these has given rise to some innovative paper restoration projects as well as a research-based teaching workshop and a special focus on measures to safeguard our cultural heritage. The historical library building itself and many of the outstanding objects in its collection, including Martin Luther's first complete edition of the Old and New Testament, both enjoy UNESCO World Heritage status (fig. 19). The new stacks and modern Study Centre opened in 2005, while the damaged historical building was repaired and restored, allowing it to be reopened in 2007. The superb premises now at the library's disposal thus span several epochs: from the Renaissance Hall to the Rococo, from the medieval Book Tower to the modern Book Cube. Among the innovations on offer to visitors here starting in 2022 will be the exhibition *Cranachs Bilderfluten* in the Renaissancesaal and guided tours through parts of the historical building that have hitherto been closed to the public but promise a glimpse of various niche collections, such as the Military Library. Visitors will thus be able to journey from the sixteenth to the twenty-first century, encountering a range of interiors, stories and collections en route.

The library's founding date of 12 July 1691 was first canonised in a Festschrift of 1941 marking its 250th anniversary and recalling the 175th 'return of its entry into the Grünes Schloss' on 16 May

1766. The institution of the library under Duke Wilhelm Ernst in the early days of the eighteenth century was clearly felt to be on a par with the contribution of Duchess Anna Amalia, who by granting the library its own building in 1766 also accorded it autonomy. 'The use of a large library was deregulated', as Goethe expressed it in his *Nekrolog* (obituary) of 1807. The inaugural date is nevertheless open to doubt, given that the history of the collection and the library as an institution since 1547 has been a subject of scholarly investigation. The larger context of the Festschrift of 1941 also plays a role here, its invocation of the 'heroic age of the German spirit' being part of a more general effort to commit what was then the Landesbibliothek to 'the great political and historical questions facing our people and our times' – in other words, to a nationalist agenda. The history of the library and its collections in the twentieth and twenty-first centuries, including their political co-opting as evidenced by the choice of 1691 as the library's founding date, will doubtless be the subject of future research projects.

RL

Fig. 19 | Title page of the Weimar Luther Bible, 1534, shelf mark Cl I : 58 (b)

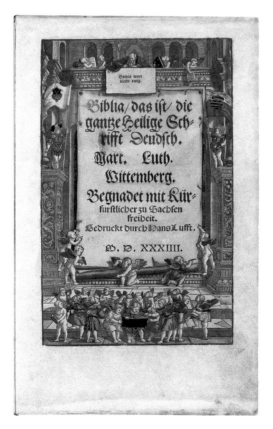

Study Centre, facade of the Book Cube

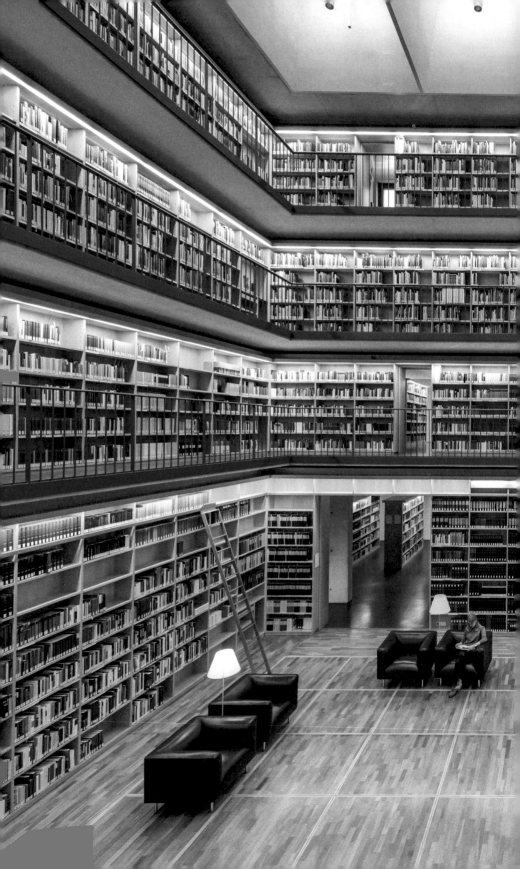

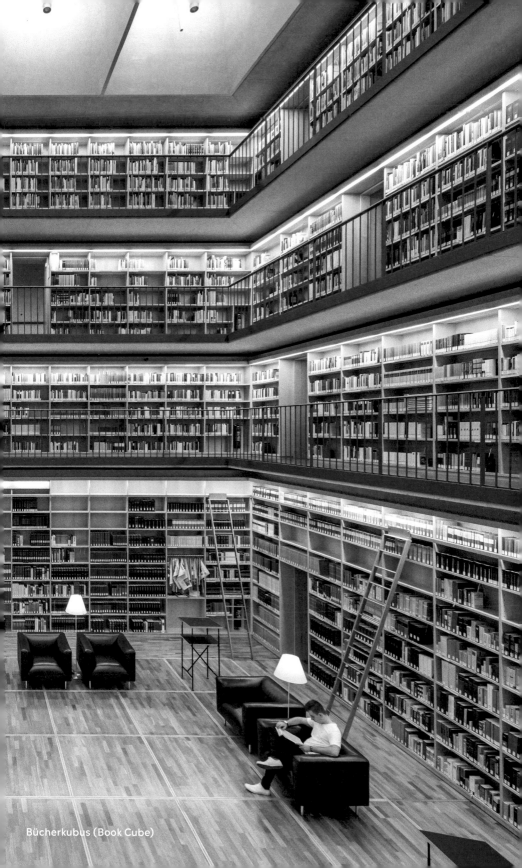

Bücherkubus (Book Cube)

TOUR OF THE LIBRARY
AND ITS COLLECTIONS

Situated close to the Park an der Ilm on the threshold between the city and park is the campus of the Herzogin Anna Amalia Bibliothek (Duchess Anna Amalia Library), which is comprised of the historical building housing the famous Rokokosaal (Rococo Hall), the Study Centre with its modern Bücherkubus (Book Cube) opposite it and the stacks underneath the Platz der Demokratie linking the two together (fig. 1). The ensemble dates from the sixteenth to the twenty-first century, the historical Grünes Schloss (Green Castle) having been altered and enlarged over the centuries. The tripartite division is clearly visible: adjoining the main building containing the Rokokosaal to the south is a somewhat lower extension. This was built at the instigation of Johann Wolfgang Goethe to accommodate the growing book collection and therefore bears his name. Completed in 1805, it connects the original Grünes Schloss (Green Castle) to a medieval tower that was once part of the city's

Fig. 1 | View from the Study Centre over the adventure portal to the historical library building

defences. The years 1821 to
1825 saw this tower remodelled
as a Bücherturm (Book Tower)
and furnished with a neo-
Gothic porch (fig. 2).

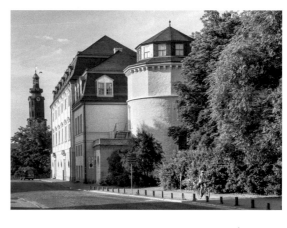

Fig. 2 | Historical
library building,
with Book Tower

Today's main entrance is
on the north side of the Grünes
Schloss and leads into the
most recent extension, which
was built in 1849 from plans by the architect Clemens Wenzeslaus
Coudray to improve the library's fire safety and accessibility.
Coudray aligned his extension with the existing façade, which is
why it is barely perceptible from the outside. On the inside, how-
ever, the difference in height between Coudray's stairwell and the
foyer along with the vaulted ceiling signal to visitors that they
are now entering the oldest part of the complex. The castle that
would later be called the Grünes Schloss was built between 1562
and 1565 as a residence for Johann Wilhelm of Saxe-Weimar,
brother of the reigning duke, and his wife Dorothea Susanna.

Today's foyer stands on the site of what was then the portico,
whose open-sided arcade afforded access to the garden fronting
the castle. That formal garden, laid out in the Italian-French style
with an eye-catching fountain at its centre, occupied the whole
of what is now the Platz der Demokratie.

The arcade was probably
walled off in the early eigh-
teenth century so that the newly
enclosed space might be put to
some other use, and it was here
that the reading room of 1937
was installed. It is also here that
the reception area for visitors is
located, and has been ever since
2007, when the library reopened
following the restoration work
necessitated by the fire of 2004
(fig. 3).

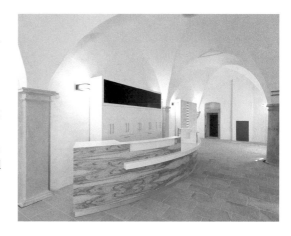

Fig. 3 | The remodelled foyer

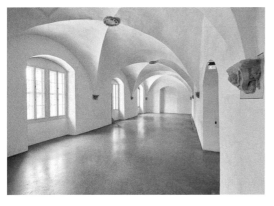

Fig. 4 | The Renaissancesaal (Renaissance Hall)

Our tour of this historical part of the library begins in the Renaissancesaal (Renaissance Hall), now used as an exhibition space (fig. 4). This hall has remained virtually unchanged since it was first built in the sixteenth century. Even the plaster on the walls is for the most part original and hence worthy of protection. The alabaster keystones of the vaulted ceiling show the coats of arms of both the duke and his consort, while the corbels feature allegorical depictions of the duke's development from fledgling child to virtuous ruler (figs. 5 and 6). The wrought-iron window gratings date from the time of building. As the blinds have to be kept closed to protect the exhibits, this feature can only really be appreciated from the outside. Viewed from the park, the messages worked into the gratings can be deciphered as the initials of the duke and duchess who had the castle built and the family motto (fig. 7):

G*S*M*T = Gott sei mein Trost (God be my comfort)
D*S*H*z*S = Dorothea Susanna Herzogin zu Sachsen (Duchess of Saxony)
I*V*G = Ich vertraue Gott (I trust in God)
H*W*H*z*S = Johann (Hans) Wilhelm Herzog zu Sachsen (Duke of Saxony)

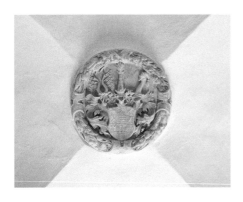

Fig. 5 | Keystone with the coat of arms of Duke Johann Wilhelm I in the Renaissancesaal

Fig. 6 | Corbel with eagle symbolising just and virtuous rule in the Renaissancesaal

The renovation of the Renaissancesaal brought to light traces of the previous paintwork, including the remains of a mural dating from the early eighteenth century.

Since 2007 the Renaissancesaal has been used for temporary exhibitions, and it is here that *Cranachs Bilderfluten* (Torrent of Images) will be shown in 2022. Given that the Renaissancesaal was finished just a few years after the death of Lucas Cranach the Elder, it is impossible to imagine a more suitable venue for this show, at least in Weimar. It certainly lends the exhibits an authentic setting. The eighty-year-old Lucas Cranach the Elder came to Weimar in 1552 as part of the retinue of Johann Friedrich the Magnanimous. Over the preceding decades, he and his son, Lucas Cranach the Younger, and their many assistants had established what we would now call the Cranach 'brand', producing a hitherto unprecedented number of paintings. With outstanding exhibits drawn from the collections of the Klassik Stiftung Weimar, the show paints a vivid picture of Cranach's many different visual worlds. Amongst them are his portraits of Johann Wilhelm's mother, Sibylle von Kleve, of Martin Luther in the guise of Junker Jörg and a medal showing Elector Johann Friedrich the Magnanimous (figs. 8 and 9). Cranach's images are also to be found in countless books and pamphlets, a selection of which is also included in the exhibition, the jewel in

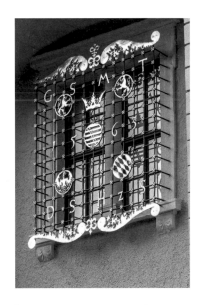

Fig. 7 | Ornamental gratings on the windows of the Renaissancesaal

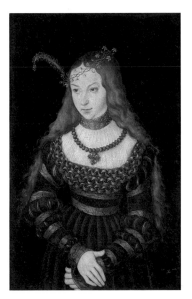

Fig. 8 | Lucas Cranach the Elder, Sibylle von Kleve as Bride, 1526, KSW, Museen, inv. no. G 12

Fig. 9 | Lucas Cranach the Elder, Martin Luther as Junker Jörg, c. 1521–1522, KSW, Museen, inv. no. G 9

45

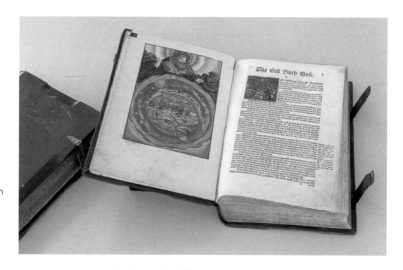

Fig. 10 | Depiction of the Creation story in the Weimar Luther Bible of 1534, shelf mark Cl I : 58 (b)

the crown being the lavishly illuminated Luther Bible of 1534 illustrated by assistants from Cranach's workshop (fig. 10). The three full-length portraits of the electors Friedrich the Wise, his younger brother Johann the Steadfast and Johann's son, Johann Friedrich the Magnanimous, moreover, are in a sense returning home, having hung in the Grünes Schloss as early as 1572, even if in those days in a room on the first floor (fig. 11).

After our visit to the exhibition *Cranachs Bilderfluten,* we leave the Renaissance behind us. To reach the Rokokosaal, we first have to return to the Coudray Extension to the north, which incidentally opened on the centennial of Goethe's birth in 1849, and there climb the stairs to the first floor. The two rooms preceding the Rokokosaal used to house the lending desk and reading room but today provide information about the history of the library, its collections and its premises.

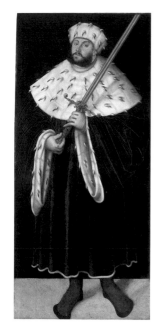

Fig. 11 | Lucas Cranach the Elder (workshop), *Johann Friedrich the Magnanimous, Elector of Saxony,* c. 1540–1545, KSW, Museen, inv. no. G 17

Christoph Leutloff's life-size portraits of the duke and duchess who had the castle built also show two of the most important buildings of the period. Behind Dorothea Susanna stands the Grünes Schloss as it must have looked in the sixteenth century, its façade decorated with extravagant sgraffito and with a small tower for a spiral staircase that has not survived (fig. 12). Visible over the shoulder of Johann Wilhelm is Schloss Hornstein, one of the ducal castles that preceded today's Stadtschloss (fig. 13). Johann Wilhelm

46

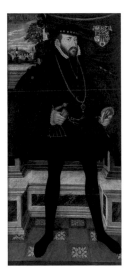

selected it as his residence and as the first real home of the ducal book collection after his defeat in the Schmalkaldic War of 1547, which led to his being stripped of his electoral status.

Proceeding northwards, the second room we come to commands views of today's Stadtschloss. The large likeness of Anna Amalia on display here reinforces the connection and serves as a reminder of the crucial role played by the duchess in the library's development. It was she who had the Grünes Schloss remodelled after plans by the master-builders Johann George Schmid and later August Friedrich Straßburger. It was also she who in 1766 tasked the librarian Johann Christian Bartholomäi with the transfer of the book collections from their three rooms in the Residenzschloss to the new 'great hall' of the Grünes Schloss.

Fig. 12 and 13 | Christoph Leutloff, *Johann Wilhelm and Dorothea Susanna, Duke and Duchess of Saxe-Weimar*, 1575, KSW, Museen, inv. nos. G 2237 and 2333

The painting, which is a copy after a work by Johann Georg Ziesenis of 1769, shows the widowed duchess at the age of thirty with her insignia of office as regent and with attributes attesting to her interests and activities as a patroness of the arts (fig. 14). The coat of arms, for example, references both her own ducal status and her guardianship of her son Carl August. The harpsichord with visible sheet music points to her passion for music, since she is known to have possessed a formidable collection of musical treasures as well as composing herself. The subject herself, who is portrayed staring straight back at us, is fashionably clad and, significantly, holds an open book in her left hand. Not only did she already have a private library numbering over 5,000 volumes by then, but by having that library installed in a dedicated space she promoted public access to it and fostered its autonomous development.

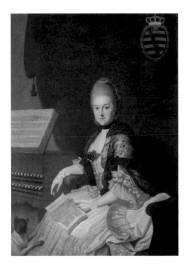

Fig. 14 | Johann Ernst Heinsius, Anna Amalia, Duchess of Saxe-Weimar-Eisenach, copy after Johann Georg Ziesenis, after 1769, KSW, Museen, inv. no. KGe/00897

47

Scholars active at court such as Christoph Martin Wieland and Johann Gottfried Herder, for example, are known to have worked with its collections. Nor should the pug dog on the left of the picture be overlooked, since it symbolises the duchess's sympathies with the cross-dynastic conviviality of the Order of the Pug, a pan-European, pseudo-Masonic order.

Fig. 15 | Supralibros on a book from Duchess Anna Amalia's private library

Fig. 16 | Charred book with scorch marks, restored, shelf mark Scha BS 4 B 000311 (2)

The portrait watches over a room full of books with ornamental bindings and other hallmarks of a princely library. There are also books and manuscripts that do not belong to the Rokokosaal to be found here: examples of some of the great collections on Weimar Classicism around 1800 as well as bibliophilic editions, manuscripts and some of the charred books salvaged from the ashes of the fire of 2004 that have since been restored (figs. 15 and 16). To reach the Rokokosaal we now have to return to the first

room, past the model of the library campus showing the Grünes Schloss with the rooms containing the collections, the stacks underneath the Platz der Demokratie, and the Study Centre installed in the complex opposite.

Behold, the Rokokosaal!

A double door takes us into the famous Rokokosaal, which, with its galleries, stucco work, busts, paintings and shelves full of books, is a glorious, festive sight to behold (fig. 17). Anna Amalia's

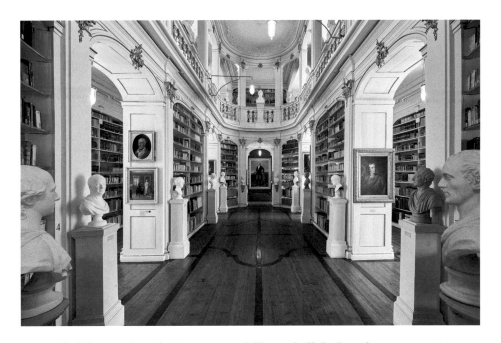

master-builders endowed this very grand library hall designed in the Rococo style with sweeping, dynamic, light-flooded forms, twelve pillars, capitals and countless ornaments. The open oval in the middle affords us a view of the galleries above (fig. 18). Prior to the fire of 1774, the Baroque Festsaal (Banqueting Hall) of the ducal castle had been similarly oval in shape and had likewise had galleries offering views of the dome above. Just as that interior had served the self-aggrandizement of the court, so the new library hall was more than just a place to keep books, being also a visual glorification of sovereignty and knowledge.

Hanging at the far end of the Rokokosaal, opposite the entrance, is an instantly eye-catching, life-size portrait of Duke Carl

Fig. 17 | Looking into the Rokoko-saal (Rococo Hall)

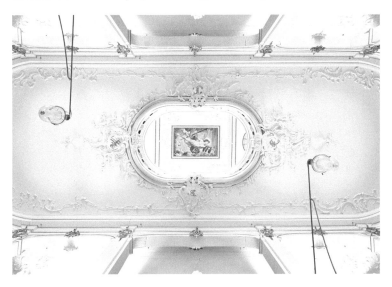

Fig. 18 | Oval ceiling of the Rokokosaal with the painting *Genius des Ruhms*

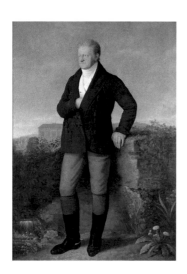

August. Attired like a member of the landed gentry, he stands in the Park an der Ilm, the Roman House at his back symbolising both his own built legacy and his erudition and promotion of Classicism. The park, which he had remodelled just like the interior of the Herzogliche Bibliothek (Ducal Library), is visibly flowering, and there is a gushing stream at his feet (fig. 19). This painting, with its window onto the world of nature, the work of the Weimar painter Ferdinand Jagemann, has welcomed guests to the library since 1805. The portraits flanking it are all of members of the ducal family. The busts mounted on pedestals actually created a new sight line, effectively realigning the whole space and lending it a classical look that paralleled that of the newly built Festsaal of the ducal castle. It was a staged order, created at a time of great unrest and in the face of the many perils posed by the French Revolution and the Napoleonic Wars. The ceiling painting is part of the same programme. Painted after a work by Annibale Carracci, Johann Heinrich Meyer's *Genius des Ruhms* had initially been destined for the interior of the Roman House. But its allusion to the glory assured to all who promote the arts and sciences made it the perfect ceiling feature for the new library hall. The original was sadly destroyed in 2004, and the work installed in its place is a copy dating from 2007, seen here with a picture of what was formerly a fully functional wind rose behind it. Both are part of the second gallery that was almost completely destroyed by the fire of 2004 and that since being restored is no longer used to store books. The room is now named after the writer and librarian Christian August Vulpius and his sister Christiane, wife of Goethe, who in those days was in charge of the whole institution. The visible scorch marks on the balustrade of the Vulpius Gallery are a sobering reminder of the fire of 2004 and of the restoration of the building headed by the architect Walther Grunwald. The second gallery is now used as an exhibition space for valuable objects and for work on the Graphische Sammlung (collection of prints and drawings) (fig. 20).

Fig. 20 | Memorial
to the fire of
2004 on the
Vulpius Gallery

References to the present have been a defining influence on
the Rokokosaal ever since it was completed in 1766; hence the
ceiling rocailles containing the gilded monograms of both the
duchess who commissioned it, Anna Amalia, and her sons Carl
August and Constantin Ferdinand, even if those of their deceased
father, Ernst August Constantin, are missing. The large-format
portrait of Carl August also went on display during his lifetime,
in 1805. On a visit to the Rokokosaal in the latter days of the
eighteenth century, the library connoisseur Friedrich Karl Got-
tlob Hirsching noted the 'portraits of the old dukes and electors
of Saxony and other royal and princely persons', but was even
more struck by the 'busts of now-living men of letters sculpted in
stone and plaster by the skilled hand of Herr Klauer, sculptor to
the court'. These busts vary in quality and material, ranging from
marble and plaster to clay and limestone. Some were made by the
aforementioned Martin Gottlieb Klauer, others by Carl Gottlob
Weißer and such celebrated artists as Jean Antoine Houdon and
Pierre-Jean David d'Angers. The implied contemporaneity of lead-
ing figures at court with the heads of living scholars and writers
is one of the remarkable features of the Rokokosaal and calls to
mind the Walhalla project by the Bavarian King Ludwig I, even if
the Halle der Erwartung (Hall of Expectation) that he envisaged

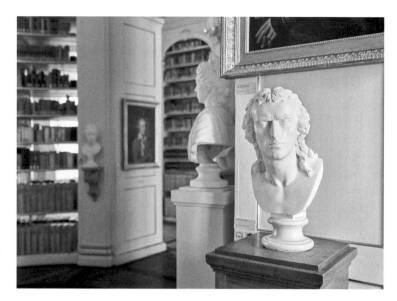

was to house the busts of living individuals singled out for this honour only after their demise.

Looking into the inner oval of the Rokokosaal, we see an even larger company of courtiers, including the lady-in-waiting Luise Ernestine von Göchhausen at front left and Adam Friedrich Oeser as a representative of the arts at centre right. The bust of Schiller by Johann Heinrich Dannecker marking the terminus of the right arc of the oval at front right was ceremoniously installed in 1826 and 'Schiller's skull' deposited in the pedestal at the same time (fig. 21). One year later this relic was transferred to the new ducal vault in what is now called the Historischer Friedhof (the Historical Cemetery).

The grandeur of the Rokokosaal is generated using very ordinary materials such as spruce, plaster and sheet metal. What these also stage for us, however, is a fragile cosmos that enables us to see and appreciate how the knowledge stored here is ordered. The version of the Rokokosaal that was reconstructed between 2004 and 2007 is that of the year 1850. It provides space for some 40,000 volumes belonging to the Herzogliche Bibliothek, organised by subject and library, the libraries of the duke himself and

great scholars such as Konrad Samuel Schurzfleisch and Friedrich von Logau having been kept separate when the books were first transferred to the new premises in 1766. The Rokokosaal is still a vast reservoir of knowledge and boasts a polyglot Bible collection, source editions, authorial editions of the ancient classics, early modern cosmographies, such as those of Sebastian Münster, and shorter treatises, such as the one on a tablet of Carolingian inscriptions in Thuringia. The records of the library's lending activities and its visitors' books show how heavily frequented it was, which is why, on taking charge of it in 1798, Goethe had new library rules drawn up and displayed for all to see. These days, the volumes in the Rokokosaal can be ordered using the online catalogue and read in the reading room of the Study Centre or viewed electronically via the digital collections.

The spectacular library hall thus fulfils two different purposes: it is a storeroom and showcase rolled into one and as a museum also functions as part of the collective memory. Its marketing as a tourist attraction began early on in its history, as is evident from the fashion magazine *Journal des Luxus und der Moden*, which reported on both the rehanging of Jagemann's portrait of Carl August and the installation of Dannecker's bust of Schiller. For court sculptor Martin Gottlieb Klauer, moreover, it was a showroom in which to advertise his wares. The commodification of Weimar Classicism, in other words, developed and was promoted early on. A door in the south wall will now take us into the 'Goethe Extension'.

The World of the Bücherturm

This extension, built at Goethe's instigation in the years 1803 to 1805, was the first serious enlargement of the library. It extended the main building southwards as far as the neighbouring tower that had been part of the medieval city walls, and with its entrance and stairwell provided a new point of access to the Rokokosaal. Once the Napoleonic Wars were over, the tower was converted into storage space for the library and was used as such from 1825 onwards. A neo-Gothic porch was also added to provide a connection between the library building, the Goethe Extension, and the tower.

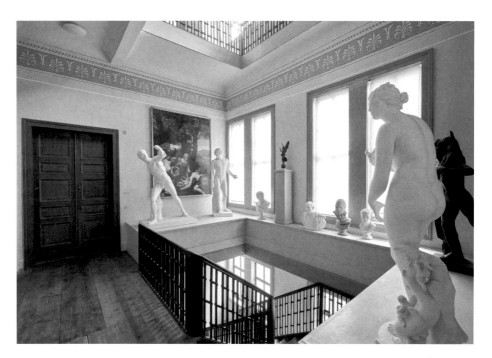

Fig. 22 | Stairwell of the Goethe Extension

Just as the medieval bastion had been integrated into the new ducal castle built to replace the old Residenzschloss, so here did Carl August and Goethe seek to combine the old with the new. The Goethe Extension and the Bücherturm can be visited as part of a guided tour.

The inauguration of the new extension shifted the main entrance to exactly half way between the Grünes Schloss and the medieval tower. The stairwell of the Goethe Extension has been preserved just as it was originally. Displayed on the first-floor podium are some of the items belonging to the ducal collection of antiquities. These statuettes, statues and busts belong to the canon of ancient art deemed to be of supreme importance to the teaching of Graeco-Roman Antiquity in the age of Classicism (fig. 22).

Passing through the buildings connecting the castle and tower, we notice the fork in the path that lends the complex its bipartite structure. On the one side is the eighteenth-century Rokokosaal, a 'shrine' to German Classicism; on the other is the tower, whose nineteenth-century interior is stocked with works that query the conventional view of Weimar as the 'cradle of Classicism'. What few people know, even today, is that this tower also houses Germany's most comprehensive military library of the late eighteenth

and early nineteenth century to have survived in its original state. Yet the more Weimar was styled the city of Classicism, the more this Militär-bibliothek was forgotten.

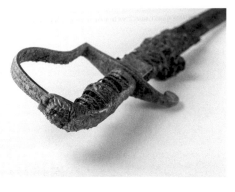

The first floor of the Goethe Extension, which is on the same level as the first gallery of the Rokokosaal, leads to a 'through room to the tower'. This originally contained an ancestral picture gallery with portraits of the dukes of Saxe-Weimar, but today houses the Militärkabinett (Military Cabinet), which serves as an introduction to the holdings kept in the tower. The key exhibit here is a lion's-head sabre of the kind carried by officers of the dragoons or hussars between 1830 and 1850, which was unearthed in front of the library in 2005 (fig. 23). Although bent, weathered and corroded, the weapon has survived intact. Its damaged condition makes it a fitting symbol of the violence that all armed conflict unleashes. As if to complement it, the cabinet also contains a topographical model referencing Weimar's history as a major military base from the eighteenth to the twentieth century.

Fig. 23 | Lion's-head sabre, c. 1830–1850, partially restored, KSW, Museen, inv. no. Kg-2014/127

This anteroom also has an outside door leading onto the roof of the neo-Gothic porch connecting castle and tower, and from there, along the Herzogsteg (Duke's Walkway), into the second gal-

Fig. 24 | Herzog-steg (Duke's Walkway) to the Bücherturm (Book Tower)

lery of the tower (fig. 24). The tower's three galleries are accessed by a spiral staircase, which in the nineteenth century was called the 'Naturtreppe' ('Staircase of Nature') and can be found on historical postcards. It turns on a twelve-metre-high spindle dating from the seventeenth century that originally stood in Osterburg Castle in Weida, Thuringia, and is the subject of many legends. In a diary entry describing a visit to the library in July 1912, Franz Kafka mentions this 'staircase fashioned by a convict out of a mighty oak tree without using a single nail'. Today it is not open to the public.

According to the original concept underlying the Bücherturm, which has shelf space for some 20,000 volumes, the lower levels were reserved for natural history, physics, ethnography and geography, including many works on botany, zoology and the flora and fauna of certain regions or lands. Another focus were the works on physiognomy and the portrait collections housed on the first gallery, whose thematic affinity with the portrait busts in the Rokokosaal reinforced the coherence of the complex. Installed on the ground floor was the cabinet with fireproof iron doors built specially to accommodate the ducal Münzkabinett (Coin Cabinet). Since the early twentieth century, this floor has also housed most of the items in the globe collection (fig. 25).

Fig. 25 | Globe collection on the ground floor of the Bücherturm

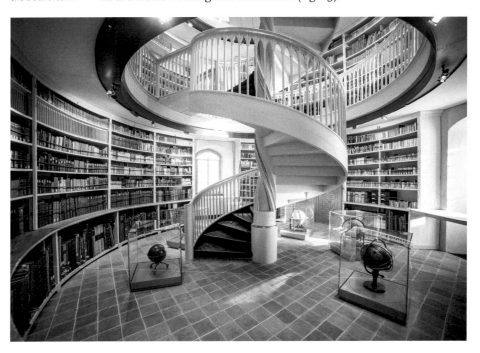

The Militärbibliothek was housed on the top floor of the tower. This organisation of the holdings – natural history below, military history above – has been retained to this day and might perhaps be read as evidence of an understanding of war as a physical *force majeure* or natural disaster. After all, recent research has revealed that Goethe did indeed regard the Napoleonic Wars, and

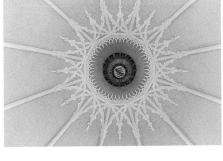

even Napoleon himself, as *physical* causes and effects – that is, as a kind of natural force. Weimar's library tower was presumably conceived as a storehouse in which the relationship between elemental violence and order might be reflected on – but in such a way that warfare would be viewed as comparable, or at least adjacent, to neighbouring natural history. The arrangement of the collections in the tower can thus be read as a manifestation of classical notions of war.

Fig. 26 | Keystone with the Saxon coat of arms and monogram of Carolus Augustus inside the dome of the Bücherturm

Underneath the tower's pointed dome is the vaulted ceiling of the Militärbibliothek, whose twelve segments converge on a sun-shaped keystone bearing Duke Carl August's coat of arms (fig. 26). The heavenly symbolism of the dome is further enhanced by the skylights. Here, looking up is like gazing into the firmament. There is thus a cosmology inscribed into the tower that lends its interior a universal dimension, connecting man and nature.

En Route to the Bücherkubus in the Study Centre
A ground-level door in the Bücherturm leads into the neo-Gothic porch, which in turn takes us through the Goethe Extension and the foyer back to the entrance. There, we descend the staircase leading down to the lower level that formerly housed the castle kitchens.

Visitors on guided tours are escorted through an underground passageway past the stacks to the Study Centre and the modern working library. Work on the two-storey underground stacks began in the year 2001. By the end of the 1990s, the library's holdings had increased to 910,000 volumes, and to manage all these books the library was having to operate several external storage

facilities. A larger, centralised magazine was urgently needed. The new structure installed underneath the Platz der Demokratie has room for a million volumes. The books kept there are shelved in stacks mounted on rails, allowing them to be shunted together to save space (fig. 27). Were all the books in the stacks to be lined up in a row, it would be twenty kilometres long! There is also a book conveyor system running from the stacks to every level of the library.

Fig. 27 | The new
stacks

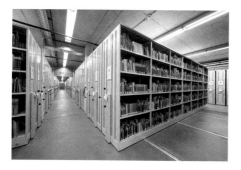

The construction and renovation work needed for today's Study Centre began at the same time as the installation of the stacks and was overseen by the architects Hilde Barz-Malfatti and Karl-Heinz Schmitz. An existing ensemble of historical buildings representing several different periods had been earmarked for this purpose. The two oldest buildings in this ensemble are the Renaissance 'Rotes Schloss' (Red Castle) and the Baroque 'Gelbes Schloss' (Yellow Castle), while two neo-Classical gatehouses and the Neue Wache (New Guardhouse), both designed by Clemens Wenzeslaus Coudray in the first half of the nineteenth century, are also part of the complex. The

Fig. 28 | Reading
area looking onto
the park

architects then designed the Bücherkubus, a cuboid building with three galleries, to be inserted in the courtyard in between.

The Study Centre was inaugurated in 2005. It provides reading areas with 130 workspaces and its shelves are stocked with 170,000 volumes organised by subject that library users can read and consult at their leisure. Anyone aged fourteen and over can sign up to be a library user.

The corridor alongside the stacks leads to the reading area called the Lesebereich Park, whose row of narrow windows looks out onto the Park an der Ilm. The workspaces set up under these windows make this an attractive place for study (fig. 28).

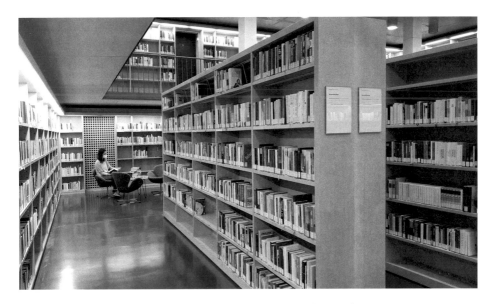

At the end of the reading area the corridor veers left and opens into the Bücherkubus, which is at once the heart of the Study Centre and the Rokokosaal's modern pendant. The lowest level of the Bücherkubus is dedicated to novels (fig. 29). Its 17,000 works of contemporary fiction can be borrowed for up to four months at a time. Thanks to the glass roof, users looking up from the desks or the reading area at the rear can watch clouds sailing by or even do some stargazing.

Fig. 29 | The library's novel collection

A staircase leads up to the second gallery, the Galerie der Sammlungen, which is basically a display window for the library and its collections. The historical reference works from the eighteenth to the twentieth century exhibited here both to the left of, and opposite, the entrance exemplify the historical ordering of knowledge (fig. 30); hence the prominence in this section of the great encyclopaedias such as Brockhaus, Meyer, Pierer and Britannica, which with their multiple volumes and plethora of cross-references offer telling visual testimony to both the gain and loss of knowledge. Amongst the reference works are two shelves devoted to a selection of works from Anna Amalia's own private library. Beautifully bound in brown calf's leather decorated with

Fig. 30 | Galerie der Sammlungen (Gallery of the Collections)

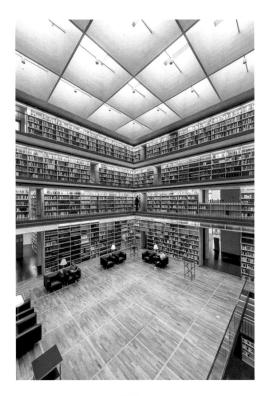

Fig. 31 | Bücher-
kubus (Book
Cube)

gold tooling, these serve as exam-
ples of the princely collection that
formed the rootstock of today's li-
brary.

Opposite these shelves on the
north side of the gallery are parts
of the working libraries of various
scholars and scientists, amongst
them the Shakespeare collection of
a scholar of English literature, the
Goethe collection of a political sci-
entist, and the Nietzsche collection
of a sociologist. That these libraries
were well used is evident from the
notes and references and other read-
er's marks still visible between the
pages.

Finally, located on the east side
of the gallery, is a reference library
on the subject of the Buchenwald
concentration camp. Positioned
here in the symbolic centre of the
building, it serves as a reminder of the crimes committed by Nazi
Germany and of the uncomfortable truth that the library itself was
part of the system of Nazi-approved cultural institutions.

We have now arrived on the ground floor of the Study Centre,
which is the library's information and communications hub. From
here we can view all three of the galleries surrounding the Bücher-
kubus as well as enjoy ready access to some 40,000 books along
with numerous regional and national newspapers (fig. 31).

The Bücherkubus forms the communicative heart of the Study
Centre and as such is constantly being transformed into a venue
for events and encounters. Here, readings and lectures, panel dis-
cussions and public colloquiums alternate with concerts and offi-
cial functions and ceremonies. Mounted on its raw concrete outer
walls are various presentation spaces for temporary exhibitions
related to the collections. The installation on the east side of the

building of Hannes Möller's *Aschebücher*, by contrast, is permanent. His artistic interpretation of the book fragments salvaged from the ashes of the fire of 2004 makes for a haunting reminder of just how fragile our cultural heritage is (fig. 32).

The reading room on the north side of the Study Centre contains both a row of workspaces and display cases for mini-exhibitions. Here there is also a seminar room and a makerspace in which users are invited to make creative use of the library's digital infrastructure. Opposite it is a reading lounge, whose flexible seating can be rearranged so as to facilitate leisurely reading, working and relaxing. It is here that the entrance to the Vodafone Lecture Hall – a room for lectures, training sessions and talks – is located.

The Study Centre is equipped with modern scanners and photocopiers, readers for microfiche and film, a wide range of media systems and workspaces for blind or visually impaired users. The thirty computer terminals all have internet access and can be used for both autonomous and guided catalogue and database searches. There are also six PC-equipped cabins known as 'Carrels' that can be rented upon application and provide users of the library with a private space for reading and studying with views of the Park an der Ilm (fig. 33).

Set up on the ground floor is a miniature library on one specific theme that changes every year as well as a shelf displaying the library's most recent acquisitions. Another unique feature of this part of the library is the 'Bücherbahnhof' (book station) for transparent accessioning. This is where large consignments of books first arrive in order to be cleaned and prepared for further processing (fig. 34).

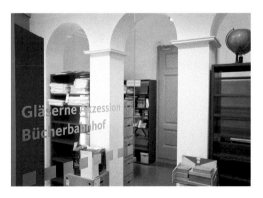

The first-floor reading room, with its thirty-two workspaces, is intended mainly for users wishing to consult books that may not be removed from the premises. Amongst

Fig. 33 | Transparent accessioning at the 'book station'

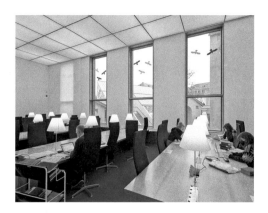

Fig. 34 | Reading room

these are works from the library's special collections – manuscripts, sheet music, atlases and maps, for example – which can be perused at the extra-large workspaces at the front. Displayed on the wall at one end of the reading room is a work by the photographer Candida Höfer. It is an image of the Rokokosaal that resonates perfectly with the view from the tall windows, which look out onto the Study Centre courtyard and towards the Grünes Schloss housing the Rokokosaal opposite. On exiting the reading room, visitors can climb a staircase to the second and third galleries of the Bücherkubus.

Our tour ends in the foyer, which is where the information desk and lending services are located and where members of the public can register as users. It is also the main entrance for all users and guests of the library's Study Centre (figs. 35 and 36).

AB | RL | VS | CS

Fig. 35 | Foyer of the new Study Centre

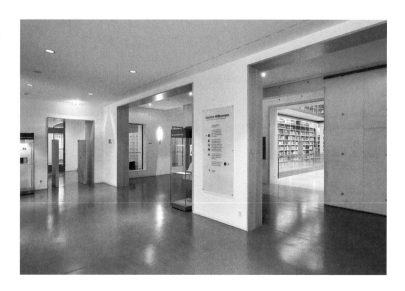

Fig. 36 | Study Centre

Friendship

This seventeenth-century 'friendship album' belonged to August
Erich of Eisenach. After studying painting in Nuremberg and
Augsburg, he worked as painter to the court of Moritz, Landgrave
of Hesse-Kassel, and at the court of the Danish King Christian IV
in Copenhagen. He took his friendship album with him on his trav-
els, which in 1639 brought him back to his native Eisenach, and
while in Güstrow near Rostock in 1619 had Elisabet Simsons enter
her name in it. She wrote with her mouth and the portrait of her
writing could well be a self-portrait.

Friendship albums, also called master or memory books, have
a long tradition that began in Reformation circles in Wittenberg
in c. 1550, lived on in the 'poetry albums' of the nineteenth century
and has its modern-day equivalent in social media platforms like
Facebook. Entries in friendship albums tend to follow a set for-
mula: an aphorism or rhyme is followed by the place, date, and the
name of the 'friend', often combined with artfully done illustra-
tions in the form of watercolour paintings, coats of arms, collages,
silhouettes, pasted-in pictures or even love tokens such as locks of
hair. With their consciously staged texts and images, these entries
served as an affectionate reminder of the friends who authored
them.

With around 3,000 friendship albums dating from 1550 to
2000, the Herzogin Anna Amalia Bibliothek (Duchess Anna
Amalia Library) boasts the world's largest collection of this genre.
Eva Raffel's presentation of the collection in a *Perpetual Calendar*
created for an exhibition of 2012 can still be enjoyed as a virtual
tour today.

JW

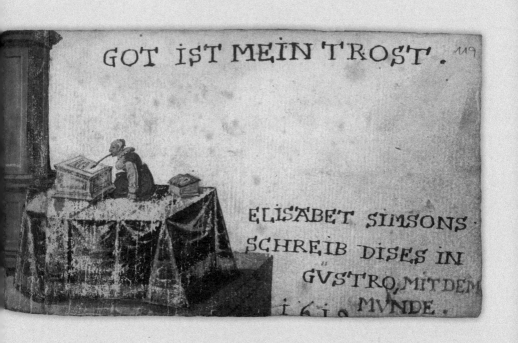

GOT IST MEIN TROST. 119

ELISABET SIMSONS
SCHREIB DISES IN
GÜSTRO, MIT DEM
1618 MVNDE.

Friendship album of the Painter August Erich from
1615 to 1662 and 1718, shelf mark Stb 474, with an
entry by Elisabet Simsons

Friendship album accessioned by the Grossherzog-
liche Bibliothek (Grand Ducal Library) between
1856 and 1897.

MANUSCRIPT MIGRATIONS – FRIENDSHIP ALBUMS AND MEDIEVAL CODICES

None of the library's collections covers such a vast timespan as does the manuscript collection. Its handwritten texts on supports ranging from papyrus and wax tablets to parchment and paper date from Late Antiquity to the present. The miscellany of languages, which includes Greek, Arabic, Turkish, Persian, Hebrew, Latin, German, French and Dutch, reflects the cultural diversity of both Europe and the Near East throughout that period. With its circa 2,000 medieval and Early Modern manuscripts and more than 3,000 friendship albums dating from the sixteenth to the twentieth century, this heterogeneous collection is a storehouse of unknown sources and discoveries. The unanswered questions raised by its digitalisation over the past three decades, moreover, have aroused the interest of scholars all over the world.

What codices – manuscripts bound between wooden covers – and printed books have in common is a functional format that facilitates their perusal by readers and archiving on shelves. The value and importance of any given manuscript are determined not

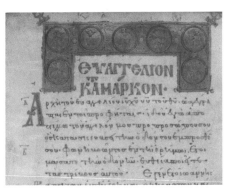

Fig. 1 | Gospel according to Saint Mark, in Greek, 14th cent., shelf mark Q 743

just by its content and the individual design of the codex, but also by the circumstances of its survival, even if these often remain in the dark. This is what the literature refers to as 'manuscript migrations'.

The oldest document in the Weimar collection is the two-part fragment (Fol 533.1) of a land lease written in Greek script and dated to the fourth year of the reign of the Roman Emperor Marcus

66

Aurelius, that is, 164 AD. It is thus a typical example of the kind of non literary, purely functional text – a category that includes wills, birth and death notices and even shopping lists – that affords us a glimpse of everyday life in ancient times. Papyrus, a material for writing on from ancient Egypt, was made from the stalk pith of a marsh plant and was used all over the Mediterranean region throughout Antiquity. The library's holdings of thirteen papyrus fragments bearing texts from the Roman and Byzantine period complement its collection of forty-two Greek codices dating from the tenth to the eighteenth century. These include Gospels (fig. 1), Bible commentaries, Psalters and texts for use in schools and centres of learning, such as Homer's *Iliad* and *Odyssey*. Amongst the twenty-nine codices that were discovered in the library attic as recently as 1997 is an almost complete copy of a sixteenth-century *Alexander Romance* (fig. 2).

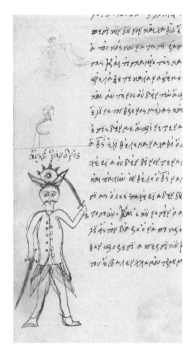

Fig. 2 | Illustration from a history of Alexander the Great, in Greek, Constantinople, 16th cent., shelf mark Q 732

This fictional narrative was widely circulated in both the Islamic world and – adapted to a predominantly Christian readership – throughout Europe right up to the modern age. It relates the early heroic exploits and all the invariably victorious battles against the Persians and Indians fought by the Macedonian general Alexander, as well as his journey to the ends of the earth. We know that the manuscript was in Constantinople in the year 1754 from the notes commenting on the text, which tell of earthquakes, the sighting of a comet, the harsh winter that caused the Bosporus to freeze over and of political events such as Sultan Osman III's accession to the throne.

The vast bulk of the Greek manuscripts and many of those in other languages come from the estate of Wilhelm Fröhner, who in 1927 left them to the Thüringische Landesbibliothek (Thuringian State Library) together with other books, brochures and prints. A native of Karlsruhe, the art historian and archaeologist Fröhner worked as a conservator at the Louvre until the Franco-Prussian

War of 1870–71, after which he stayed on in Paris and continued collecting privately.

The core of the manuscript collection, however, consists of the 240 codices from the private library of Konrad Samuel Schurzfleisch, who in 1706 was appointed the Weimar library's first director. His younger brother Heinrich Leonhard, who like him was a professor at the University of Wittenberg before becoming chief librarian in Weimar, moved to Weimar in 1713, bringing the collection with him. Schurzfleisch himself and later his heirs were forced to cede the collection to the library when the court administration tired of all the legal ruses and threats that had failed to produce the desired result and simply confiscated it.

The Schurzfleisch Collection also includes several Islamic codices, which came onto the manuscript market as 'Turkish booty' from the Ottoman Wars of the sixteenth and seventeenth centuries. The contents of these eminently portable codices with bindings resembling an envelope complete with flap range from Korans and prayers to silence the enemy (Oct 183) to anthologies of poems. What motivated the acquisition of the fifty-two Islamic manuscripts that ended up in Weimar as early as the eighteenth century and how they actually got there have yet to be ascertained. Only

Fig. 3 | Illustration from an anthology of Persian poetry, 16th cent., shelf mark Oct 168

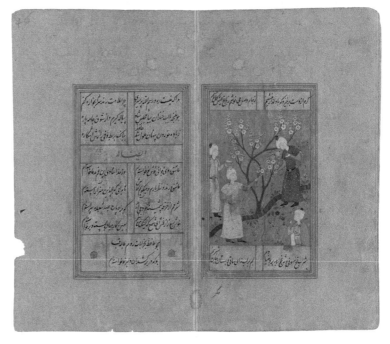

one of them bears a dedication to the Weimar library, dated 1713 (Q 667). Unlike the Netherlands, France and England, which because of their own geopolitical interests in the sixteenth and seventeenth centuries had university departments dedicated to the study of Oriental languages and literature, the German-speaking world was more likely to encounter Islamic literature only in translation. Goethe seems to have learned of the existence of the library's Islamic collection only when his work on the *West-Östlicher Diwan* in 1815 and later prompted him to have some Persian codices acquired on the manuscript market (fig. 3).

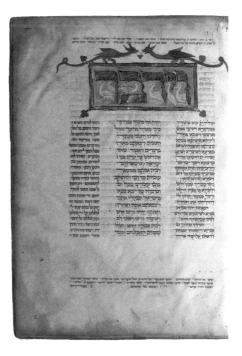

Fig. 4 | Torah in Hebrew with animal images, 13th/14th cent., shelf mark Q 652

Another treasure from the Near East is a small group of seven Hebrew codices dating from the thirteenth to the eighteenth century, amongst them a two-volume Torah (fig. 4).

The most valuable part of the manuscript collection comprises the 202 codices and 117 fragments in medieval Latin dating from the eighth to the sixteenth century. Almost half of these come from monasteries in Erfurt, from whose secularization between 1803 and the 1820s the Weimar library profited – even if more from the glut of manuscripts suddenly released onto the market than from any official re-allocation of their holdings. To these can be added the twenty-four codices from the library of Erfurt University, which was founded in 1379 and shut down by the Prussian government in 1816. Napoleon Bonaparte had given the university the remains of the libraries of the Charterhouse of Salvatorberg near Erfurt and the Benedictine Abbey of St Peter and Paul back in 1809; and that same year saw Goethe's brother-in-law, Christian August Vulpius, who was also a librarian at the Herzogliche Bibliothek (Ducal Library), open a bureau for the sale on commission of literary and artistic works, through which the trade in

such manuscripts might be transacted. Vulpius's heirs would later sell several manuscripts from his private collection to the Weimar library.

Amongst the Latin manuscripts are various theological and liturgical books (fig. 5) as well as textbooks for the teaching of medicine, jurisprudence, history and philology. The codices come from monasteries in Spain, Italy, France, Belgium, the Netherlands, England, Bohemia and Germany. Two of them belonged to the Benedictine Abbey of St Cyriacus/St Andreas in Erfurt, from which prior to the completion of the German Research Council's investigation of 1993–2010 no manuscripts at all were thought to have survived. An early print of a Missal, a liturgical book for use at mass, which was acquired for the monastery library in connection with the reforms of the Bursfelde Union in 1504, contains a handwritten addition showing a scene of nuns taking their vows (fig. 6).

Fig. 5 | Silhouetted initial 'S' on a coloured ground from a Bible commentary by Saint Jerome, France, 12th cent., shelf mark Fol max 1

Preliminary studies undertaken – initially in 1934 and then again in 1988 – to ascertain the contents of the collection of (Old) German manuscripts revealed the existence of sixty-four medieval German manuscripts and some fragments dating from the fourteenth to the sixteenth century. Some codices of exceptional importance to the history of culture have been widely publicised in selected publications. Amongst these are the prayer book of Margarethe von Rodemachern, texts from the Guild of Mastersingers and works on military and civil engineering (Fol 328). There are also hundreds of German codices to be found in the collection

of 1,400 early modern manuscripts in many different languages. In terms of content, these range from religious literature of the Reformation to texts on weaponry originating in the Thirty Years' War, armorials, chronicles, travelogues, biographies, opera libretti, plays and occult texts.

JW

Fig. 6 | Depiction of a kneeling nun signing her profession of vows, from a handwritten supplement to the *Missale Benedictinum Bursfeldense* (Speyer, 1498), shelf mark Inc 152

Printed Matter

Some three decades after the invention of book printing with movable type, Marx Ayrer began his career as an itinerant printer in Nuremberg. He specialised in the kind of small and popular booklets that were easy to sell but that, as the 'airport literature' of the day, were rarely preserved. Incunabula scholars have attributed thirty-eight publications to him. Ayrer finished printing the four-page-long prose narrative *Die geschicht dracole waide* on 14 October 1488. It tells the story of Vlad III Drăculea, a mid-fifteenth-century prince of the Romanian *voivode* of Wallachia, who has gone down in history as a cruel tyrant. One episode shows him tucking into a hearty breakfast at Kronstadt (now Brasov), rounded by the corpses of hundreds of his impaled victims. Initially spread by his political opponents, the story of *Dracole Waida* was especially widely circulated in Eastern Europe. It is also related in several early Upper German prints, the oldest of which is the one preserved in Weimar, which is also the only surviving copy of that edition. Once printed in large numbers, pamphlets like these attest to the use of book printing to sway political opinion, spread propaganda and provide sensationalist entertainment. The figure of Vlad the Impaler was not connected to the vampire myth until much later, when the novel *Dracula* by the Irish writer Bram Stoker was published in London in 1897.

KL

Die geschicht dracole waide (Nuremberg: Marx
Ayrer, 1488), shelf mark Inc 609 [a]

This incunabulum was probably part of a collec-
tion of incunabula from the library of Hieronymus
Wilhelm Ebner von Eschenbach that was acquired
at auction for the Herzogliche Bibliothek (Ducal
Library) on 2 August 1813.

OLD PRINTS – PRINTMAKING, PUBLISHING AND USE

In the mid-fifteenth century, the book was basically reinvented. Johannes Gutenberg's development of a printing press that used movable type sparked a media revolution. Texts that had hitherto had to be laboriously written and copied by hand could now be produced and circulated much faster. The cast metal type bearing letters, spacers and punctuation marks was set line by line to create a form that was then mounted on a press, inked with printing ink and imprinted onto the text support – in most cases paper. The type was then returned to the case ready to be recombined and reset for the next sheet. For centuries this was how all books were printed and it was not until 1850 that new methods of industrial book production began to appear. The term 'old prints' refers to prints printed on manually operated presses prior to that date. Preserved in the Herzogin Anna Amalia Bibliothek (Duchess Anna Amalia Library) are some 300,000 old prints from all the subject areas covered by its collections. Some ten per cent of these were lost to the fire of 2004, while a further 25,000 were among the charred books salvaged from the ashes. The resulting gaps are gradually being closed, whether through painstaking restoration or new acquisitions.

Especially worthy of mention amongst the book

Fig. 1 | Title page of the *Neu-Sprossende Teutsche Palmbaum* with a portrait of the author and composer Georg Neumark (Weimar, 1669), shelf mark D 6 : 19

collections from the age of old prints are a collection of pamphlets from the Reformation period, the libraries of Konrad Samuel Schurzfleisch and Balthasar Friedrich von Logau, the collection of historical Bibles, Caspar Binder's catechism collection, the literary almanacs and diaries and the private libraries of Duchess Anna Amalia and Duke Carl August. Another focus of the library's holdings from this period are the literary works and translations produced within the orbit of the Fruchtbringende Gesellschaft (a literary society founded in Weimar in 1617) (fig. 1), original editions of German and European literature from the period 1750 to 1850 and the publications of publishers based in Weimar (fig. 2).

The early books or incunabula (from the Latin word *cunae*, meaning 'cradle') produced prior to 31 December 1500, whose typography and book design rely heavily on the model of the manuscripts that preceded them, also occupy a special place in the collection. The Herzogin Anna Amalia Bibliothek is in possession of 428 of these works, amongst them some editions of ancient authors, Bibles, theological and philosophical works, chronicles and historical accounts and legal, mathematical and medical textbooks. The notable titles include a Latin and a German edition of the famous *Nuremberg Chronicle* by Hartmann Schedel (fig. 3), three copies of the so-called Ninth German Bible or Koberger Bible, named after its printer Anton Koberger, and the ninth of several

Fig. 3 | View of Erfurt from Hartmann Schedel's *Das buch Der Croniken vnnd geschichten*, also known as the *Nuremberg Chronicle* (Augsburg, 1496), shelf mark Inc 134

Fig. 4 | Silk binding of Friedrich Schiller's *Historischer Calender für Damen für das Jahr 1792* (Leipzig, 1791), shelf mark 19 A 12921

German Bible editions prior to Martin Luther's famous translation, Sebastian Brant's *Narrenschiff* (*Ship of Fools*) in German, Latin and French and Konrad von Megenberg's encyclopaedia, *Das Buch der Natur* (The Book of Nature). The incunabula collection also features two exceedingly rare block books, the forms for each page of which – both the text and the illustrations – were carved out of a single block of wood.

The age of old prints was a period of remarkable variety in the book-maker's craft. This is certainly true of the type used by printing shops all over Europe – such famous names as Aldus Manutius, the Giunta family of printers and publishers and Giambattista Bodoni, for example – whose works are represented in the collection; but it is also true of the bindings, since old prints were individually bound. The design of these hand-crafted bindings and the materials out of which they are made – from parchment and vellum to cardboard, silk and silver – provide clues as to the social status of the client and the function that the book was to have. Many of these volumes can be identified as the work of a particular workshop based on the bookbinding tools used and the decorative motifs applied. One especially noteworthy bookbinding shop was that of Johannes and Lukas Weischner, who in the sixteenth century did work for both the University of Jena and the ducal court at Weimar. Amongst the examples of their craft in the

Herzogin Anna Amalia Bibliothek are three magnificent bindings decorated with lacquer painting. Because old prints are always individually hand-made, there are scarcely any true duplicates in this category. The Weimar copies of Friedrich Schiller's *Historischer Calender für Damen für das Jahr 1792* (Historical Calendar for Ladies for the Year 1792), for example, all have different bindings. One especially luxurious binding made of silk printed with classical motifs in several different colours was gifted to the collection several years ago (fig. 4). Another important gift is the collection of unbound and, for the most part, unfolded printed sheets dating from the years 1737 to 1848 (fig. 5). The 497 copies spread over more than 2,160 sheets are almost all of works published by Vandenhoeck & Ruprecht. The publisher used the raw sheets to

Fig. 5 | Examples of the Vandenhoeck & Ruprecht raw sheet collection

canvas orders at the book fairs of the day, transporting them to such events inside wooden barrels.

The books belonging to the collection of old prints are lavishly illustrated, sometimes with hand-coloured prints executed using all the standard printmaking techniques of the day, such as woodcut, copperplate engraving, etching and lithography.

The books themselves are often full of clues as to their centuries-old history, including the hands through which they have passed and the use to which they have been put. A new system introduced in 1997 standardised the descriptions of such signs and marks in the catalogue of the Herzogin Anna Amalia Bibliothek in order to facilitate provenance research. Amongst the features henceforth to be included were handwritten owner's marks, ex libris, collection stamps, *supralibros*, signature plates, records of purchase prices, evidence of gifting or lending, dedications and readers' annotations such as marginalia, underscorings and bookmarks. The provenance of the first German Bible to be printed in America, for example, is a very special story. The copy in Weimar is one of twelve sent to Europe from Philadelphia by the printer Christoph Sauer (fig. 6). As the ship carrying them was attacked by pirates in the mid-Atlantic, however, the precious Bibles reached Frankfurt am Main only after a long detour. Their intended recipient was Heinrich Ehrenfried Luther, owner of the type foundry that had made the type used to print them. In 1747, Luther gave one of the twelve Bibles to Ernst August, Duke of Saxe-Weimar, presumably in the hope that he would be appointed librarian at the Weimar court.

KL

Fig. 6 | Biblia, Das ist: Die Heilige Schrift Altes und Neues
Testaments (Germantown, 1743), shelf mark CI I : 126

Revolutionary

One of the most innovative media of the early modern age was the pamphlet. Persuasive, argumentative, propagandist and penned in the vernacular so as to stir the emotions, it played an important role in the confessional, political and social debates of the period and hence was a key factor in public discourse.

The title page of the tract *Von der Babylonischen gefengknuß der Kirchen* (About the Babylonian Prison of the Churches) features a portrait of Martin Luther as a monk – complete with tonsure and habit and holding a Bible – after a well-known painting by Lucas Cranach the Elder. This likeness was to become one of the defining images of the Reformer – alongside others, such as that of Luther as Junker Jörg, Luther the preacher, the professor of theology and the good husband at the side of Katharina von Bora. This Reformist tract has him casting doubt on the Seven Sacraments of the Roman Catholic Church and citing Jesus and the New Testament as his authority for replacing these with just two: Baptism and the Eucharist.

The pamphlet's title alludes to the Babylonian Exile of the Israelites, whose fate Luther compares to that of Christians in the German-speaking lands of the Holy Roman Empire in 1520, who according to him were living in captivity to Rome and papal authority. The church historian Katharina Kunter, writing in the online magazine *Chrismon Plus* in October 2020, argues that Luther intended his pamphlet, published in 1520, to be understood ironically, as the 'preamble' to a much weightier rebuttal of the charge of heresy, the pope having shortly before threatened him with a trial, banishment and excommunication.

JW

Martin Luther, Von der Babylonischen gefengknuß
der Kirchen (Strasbourg: Schott, 1520), shelf mark
Aut. Luther : 1520 (63)

The tract is known to have belonged to the
holdings of the ducal library as early as the mid-
eighteenth century.

81

PAMPHLETS – A KEY MEDIUM OF THE REFORMATION

The pamphlet collection of the Herzogin Anna Amalia Bibliothek (Duchess Anna Amalia Library) comprises c. 2,800 items, most of which relate to the Reformation and Counterreformation, though some date from as recently as the eighteenth century and tell of earthquakes and wars, the sighting of comets and prophecies. Pamphlets can be anything from tracts and sermons to dialogues, public notices or collections of ballads and hymns. Unlike handbills or posters, they consist of several pages and can contain more than one text. Published as unbound booklets in a handy format, pamphlets were sold by peddlers and itinerant booksellers for very little money. In the eighteenth and nineteenth centuries they were circulated by colporteurs and paper boys along with other cheap printed matter such as calendars and penny-dreadfuls. The German word for them, *Flugschriften* (lit. 'flying writings') led many to imagine that they circulated by flight.

According to Johannes Schwitalla, author of *Flugschrift* (1999), their impact was greatest during the period of confessional and social strife known as the

Fig. 1 | Martin Luther, Das tauff buchlin verdeutscht (Wittenberg, 1523), shelf mark Aut Luther : 1523 (54)

Peasants' War and the first stirrings of the Reformation. Some eleven million copies of a good 11,000 pamphlets were printed alone in the period 1520 to 1526. Another pamphlet containing ideas that would change the course of history was the twenty-three-page *Communist Manifesto* by Karl Marx and Friedrich Engels, which was circulated in London in 1848.

Since it was of the essence to get pamphlets off the press as quickly and cheaply as possible, very few of them were illustrated (fig. 1). The *Sermon von dem Ablaß vnnd gnade* (Sermon of Indulgence and Grace, 1518) (fig. 2) that has been a UNESCO World Heritage document since 2015, for example, is spartan in design. In its six pages of bald text, Luther explains the *Ninety-Five Theses* of 1517, which were originally written in Latin. Criticising the church's practice of selling indulgences, for example, he argues that forgiveness cannot be commodified, but is attainable only through faith in God and the grace of Jesus Christ. Within just two years, this pamphlet, published in Wittenberg, was reprinted twenty-five times in Leipzig, Augsburg, Nuremberg, Basel and Braunschweig.

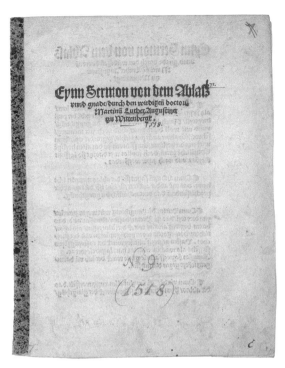

Fig. 2 | Martin Luther, Eynn Sermon von dem Ablaß vnnd gnade (Wittenberg, 1518), shelf mark Aut Luther : 1518 (9)

The development of the Weimar pamphlet collection focused on Luther and the Reformation is closely bound up with that of three related collections: Bibles (5,000 volumes), catechisms (2,000 volumes) and hymnbooks (850 volumes). Scholars can therefore draw on a wide range of sources on the Reformation, including a number of rare editions and works in the original language.

The pamphlet collection also boasts a precursor of the Christian hymnbook the *Achtliederbuch* (Book of Eight Songs) of 1524, which is pieced together out of single prints and features Luther's

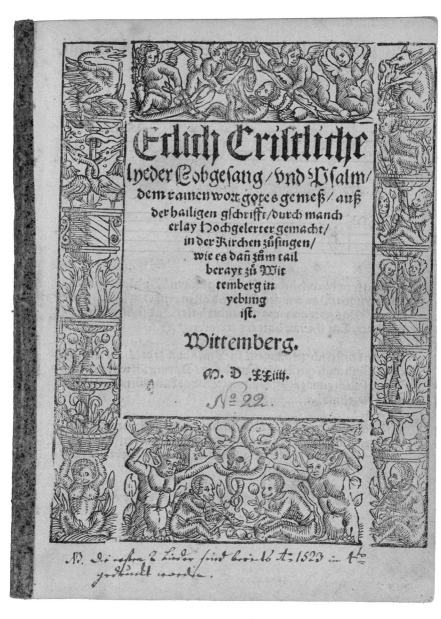

Fig. 3 | Martin Luther, Etlich Cristliche lyeder
Lobgesang und Psalm (Wittenberg [Augs-
burg], 1524), known as the Achtliederbuch or
'Book of Eight Hymns', shelf mark Aut Luther :
1524 (22)

four earliest hymn texts. While the original publication was conceived in Nuremberg, the Weimar copy is a reprint from Augsburg (fig. 3). The title page of the pamphlet announces that the contents are 'to be sung in churches, as is already in part the practice in Wittemberg'. The publication, which is directed at pastors and cantors, accelerated the development of Reformist church music and hymn singing, which the Roman Catholic mass does not envisage as a rule. Luther took the view that as religious songs, hymns should be sung in German and to popular melodies (fig. 4).

JW

Fig. 4 | 'Nun frewdt euch lieben Christenn gmayn', hymn from Martin Luther's Achtliederbuch of 1524

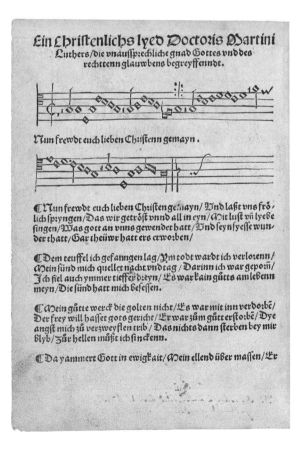

Faustian

Finely bound and highly ornate folio-format books are commonly referred to as deluxe editions. Deluxe editions of works of literature first came into fashion in Germany in the late eighteenth century. They were a reaction on the part of publishers to the cult of the poet aimed at forging a national identity. Besides being products for a new market, these volumes were also contemporary monuments, in book form, to the authors and their works.

The first deluxe edition of Goethe's *Faust* was published by Cotta-Verlag and comprised *Faust I* in 1854 and *Faust II* in 1858. The edition illustrated here combined both parts in a single volume bound in red vellum and decorated with gold and blind tooling. Bound into it are engravings after the finely detailed illustrations of scenes from Goethe's drama produced specially for this edition by the painter Engelbert Seibertz. The typography is similarly extravagant and commensurate with the prevailing taste. The volume is 42.8 centimetres high, 33.5 centimetres wide and weighs 5.7 kilos. Obviously, a book as magnificent, but also as cumbersome, as this would not be that convenient to read. It was intended to be admired, and the look and the feel of it savoured. This deluxe edition was intended for an educated, nationally conscious and financially better-off clientele. It represented not just the importance of Goethe's *Faust* to German culture, but also the social status of its owners.

RH

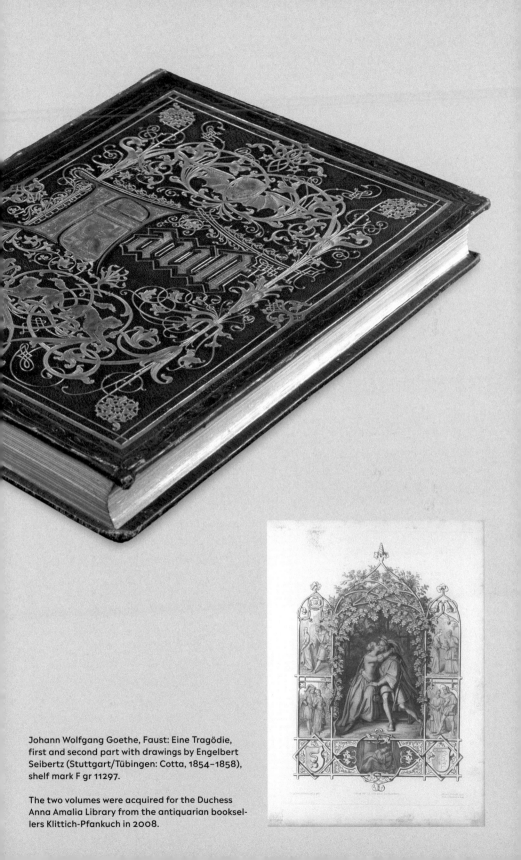

Johann Wolfgang Goethe, Faust: Eine Tragödie, first and second part with drawings by Engelbert Seibertz (Stuttgart/Tübingen: Cotta, 1854–1858), shelf mark F gr 11297.

The two volumes were acquired for the Duchess Anna Amalia Library from the antiquarian booksellers Klittich-Pfankuch in 2008.

FOCUS ON *FAUST* – ON THE HISTORY OF A COLLECTION

Anyone interested in the historical figure of Johann Georg Faust, the alchemist, astrologer and necromancer who met his death – probably in a chemical explosion – in c. 1540, and in his afterlife in literature, will find the Herzogin Anna Amalia Bibliothek (Duchess Anna Amalia Library) to contain an incomparably rich offering of materials and information. The library in Weimar in fact boasts the world's largest *Faust* collection. The history of the literary sources that prompted Johann Wolfgang Goethe to write his best-known work is copiously documented in this *Bibliotheca Faustiana*, a compendium of *Faust*-related texts. Available for consultation here are not just what few contemporary sources there are on the historical Faust, but also the *Historia von D. Johann Fausten*, the publication of which in 1587 marks the beginning of his appropriation as a literary figure. The coming two centuries saw that first chapbook followed by works in the most diverse genres – dramas, puppet plays, esoteric literature, folk tales, scholarly treatises – almost all of which are to be found in the collection.

Without question, however, the *Faust* story owes its enduring fame above all to Goethe. Not only did the great German poet study the many myths and legends surrounding this historically dubious master of the dark arts in league with the devil throughout his life,

Fig. 1 | Faust and Mephistopheles, from a series of twenty Expressionist woodcuts by Ernst Barlach for the *Walpurgisnacht* cycle published in 1923, shelf mark F gr 5279

but it was out of this material that he crafted his great drama about man's search for meaning in a world riven with contradictions. His first treatment of the subject was *Faust: Ein Fragment*, published in 1790, followed by *Faust: Eine Tragödie*, better known as *Faust I*, of 1808, and *Faust II*, which was published shortly after his death, in 1832. An even earlier version of the work, now widely known as *Urfaust*, was discovered only in 1887 and published by the German literary scholar Erich

Schmidt. The Weimar Faustsammlung (Weimar Faust Collection) is in possession of all these texts in their many different editions and translations. It also houses the vast body of secondary literature on the subject, some of it in the Faustsammlung itself, some of it in other sections of the library. Works attesting to the ideologically motivated appropriation of the *Faust* story in Wilhelmine Germany, Nazi Germany and in Communist East Germany can also be found here.

Fig. 2 | Faust and Mephistopheles in an advertisement for the 'Faust' nail-polishing stone, c. 1910, shelf mark F 4547 (6)

The core of the collection is made up of Goethe's *Faust* and discussions of the work by other authors, though other literary treatments of the legend – both contemporary and from a later period – are not lacking. Interested scholars can also form an impression of just how rich a seam the *Faust* story, and Goethe's tragedy in particular, have proved to be in both the fine arts and music. Numerous drawings, print illustrations and even comics are just as much a part of the collection as are some 600 musical compositions (fig. 1). The advertisements, postcards, beer mats, napkins and other 'merchandise' bearing *Faust* motifs and quotations demonstrate the extent to which the theme has seeped into our culture and into our everyday lives (fig. 2).

That the Herzogin Anna Amalia Bibliothek now has this treasure at its disposal is thanks to the Leipzig physician Gerhard Stumme, who even as a young man was a passionate and knowl-

edgeable collector of all things Faustian. He finally parted with his 10,250-piece collection only in 1954, by which time he was eighty-three. It was acquired by the Nationale Forschungs- und Gedenkstätten der klassischen deutschen Literatur (NFG, National Research and Memorial Sites of Classical German Literature) in Weimar for the institute's new library, one of the predecessors of today's Herzogin Anna Amalia Bibliothek. To Stumme's collection was added the much smaller *Faust* collection of German scholar Alexander Tille, whose 500 objects had been acquired by the Goethe- und Schiller-Archiv back in 1913. Still more holdings have been added steadily since 1954 so that today's Faustsammlung comprises some 20,000 objects. And thanks to the latest advances in digitalization, over 7,000 of these are already available online.

In recent years, the history of Weimar's Faustsammlung has increasingly become a subject of research in its own right. Some important new findings are presented in Carsten Rohde's *Faust-Sammlungen: Genealogien – Medien – Musealität* of 2018. The questions that have yet to be answered mainly have to do with the ori-

Fig. 3 | Ex libris in a book from the Faust Collection indicating that it once belonged to the library of Hermann Türck, shelf mark F 7967

gins of numerous objects, that is to say, their provenance. Amongst the works in the collection, for example, are various books from the private library of Erich Schmidt, editor of the *Urfaust*. It turns out that, at Schmidt's death in 1913, his library was purchased by the publisher Rudolf Mosse, who in turn died in 1920. After the Nazis seized power in the spring of 1933, Mosse's heirs, being Jewish, were threatened, expropriated and forced to emigrate. They lost everything: the family business and the family fortune, which included Schmidt's library. An antiquarian bookseller in Berlin was tasked with selling the library, and some of the items put up for sale were acquired by Gerhard Stumme. Did Stumme – whether consciously or not – make any other purchases with a similarly problematic provenance after 1933?

It is clear from another case, too, that still more books seized by the Nazis from their rightful owners ended up in the collection even after it had gone to Weimar. The volumes in this instance come from the library of Hermann Türck, a *Faust* scholar who died in April 1933 (fig. 3). His daughter, who was also persecuted because of her Jewish origins, had no choice but to sell her father's library and emigrated a short while later. Have any more objects unlawfully confiscated by the Nazis entered the Faustsammlung since 1954?

The Herzogin Anna Amalia Bibliothek's provenance research work has already led to some major restitutions, and it remains committed to the ongoing investigation of these questions and others like it in the years to come.

RH

Popular

This trilogy of novels tells the story of Rinaldo Rinaldini, a brooding, guilt-plagued, but noble-spirited 'robber captain' who lurches from one adventure, one amorous entanglement to the next. Christian August Vulpius' 'romance of the century' was published in 1799. As one of the period's best-known works of popular fiction, it spawned a whole host of fictional robbers and was translated into multiple languages.

So successful was the trilogy that Vulpius decided to continue the series. The first sequel, published in instalments in 1800 and 1801, has Rinaldini – hitherto presumed dead – enter the geopolitical arena as a freedom fighter and military commander, who also discovers that he is of noble blood. In the last novel in the series, published in 1824, he exits the world stage and returns to his band of robbers, only to be betrayed and shot dead while attempting to flee.

Christian August, brother of Christiane Vulpius and Goethe's brother-in-law, was a prolific and successful writer of what we would now call pulp fiction, with nearly seventy novels and over forty plays to his name. Nor was that all: as librarian at the Herzogliche Bibliothek (Ducal Library) in Weimar between 1797 and 1826, he was instrumental in having all new acquisitions properly catalogued and made available to users.

The first edition of his own *Rinaldo Rinaldini* of 1799 was not amongst them, however. And the library's holdings of 'Rinaldiniana' have remained patchy to this day. This third edition of the first version is the earliest work in the series known to belong to its collections.

CS

BEYOND THE CLASSICS – POPULAR LITERATURE AROUND 1800

Few libraries today carry late eighteenth-century popular literature, such as the novels and tales of Christian August Vulpius and the works of similarly successful contemporaries like Carl Gottlob Cramer, August Lafontaine and Carl Heinrich Spieß. As former catalogues show, it was not until the 1920s and 1930s that fiction written purely for entertainment was deemed worthy to grace the shelves of the library that would become the Herzogin Anna Amalia Bibliothek.

Readers in the age of Goethe who wanted a steady supply of ripping yarns, courtly romances and spine-chilling ghost stories without buying them outright had to find alternative sources. They could borrow used copies from friends or could visit one of the lending libraries that were then flourishing all over Germany and that played a crucial role in the dissemination of popular literature. These libraries were run by booksellers, who often made more money from lending books for a fee than they did from selling them. The more battered and dog-eared a book was, the more highly it was rated. As the author and librarian Friedrich Matthisson so pithily commented in his epigram *Die Leihbibliothek*: 'Wieland and Goethe are dusty, but otherwise without blemish, whereas Kramer and Spiess have no end of dirt clinging to them.'

The lending library as a business model developed in response to the growing demand of an ever-larger reading public, which in turn was fuelled by a steady increase in the number of books being printed. Technical advances in papermaking and constant improvements in the printing process were making book printing increasingly fast and cheap. Trading volumes rose steeply, and according to volume seven of the *Geschichte der deutschen Lite-*

ratur von den Anfängen bis zur Gegenwart (A History of German Literature from Its Beginnings to the Present) (1989), some 2,500 German-language novels and collections of short stories were published alone in the last ten years of the century and hence 'as many as in the four decades from 1750 to 1790'.

But what is popular literature – that is to say, literature written for entertainment only? And why was it carried by lending libraries rather than institutional libraries? Older attempts to differentiate between literary fiction and pulp fiction tended to use terms such as 'highbrow' and 'lowbrow'. The latter counted as inferior even in 1800, which explains why it is so rarely found in institutional libraries. In the absence of any collecting tradition, their holdings of such fare are bound to be patchy at best.

Since the 1970s, however, various scholars have attempted to take a more neutral and socio-historical approach to the subject. In his *Volk ohne Buch* (A People without Books) of 1988, Rudolf Schenda, for example, defines his subject as literature that is well liked, well known, widely circulated, easy to understand and cheaply and readily available.

This definition can be fleshed out by taking a literary studies perspective. According to Albrecht Classen, texts written purely for entertainment typically lack complexity and tend to be one-dimensional. They operate with shortcuts and use polarising, schematic and stereotypical figures as well as well-known themes, motifs and storylines. The principal purpose of such literature is to afford the reader effortless pleasure: hence the original variations on familiar themes. The point is not to cast doubt on the world as it is; on the contrary, the proper order of things is ultimately affirmed.

Historical pulp fiction is now a very interesting subject, not least from the sociological point of view. It is precisely because it was geared to the needs and tastes of a very broad readership and availed itself of tried and tested strategies, themes, sources and motifs to that end that it tells us so much about the times for which it was written. It reveals the desires and yearnings of its readership, even while remaining anchored in a specific period. The social order and the rules governing it are invariably a presence, if only because the protagonists – such as the figure of Rinaldo Rinaldini

in Vulpius' eponymous novel – have to set themselves up in opposition to them. Rinaldini, for example, is an outlaw who embodies the desire for freedom and adventure. In his pursuit of higher justice, moreover, he defies the prevailing laws by appointing himself to fight against injustices such as the exploitation of ordinary folk by the church and nobility. His final adventure of 1824, however, ends with him trying in vain to return to a bourgeois, law-abiding existence. His identity prompts his lover and child to abandon him, and several years later, just when it looks as if the story is going to end happily for all three of them after all, the erstwhile 'robber captain' is shot dead by soldiers. As Roberto Simanowski argues in his study of the *Medialisierung des Abenteuers* (Medialization of the Adventure), the societal norms that were temporarily suspended are reinstated. Yet it is this same pattern, he argues, that makes these books so charming and such a delight to read. Readers are offered a brief period of respite in which they can imagine a life of freedom and danger – only to have the superiority of their own boring, law-abiding lives ultimately confirmed.

Fig. 1 | Christian Heinrich Spieß, Das Petermänchen: Geistergeschichte aus dem dreizehnten Jahrhunderte, Erster Theil (Frankfurt/Leipzig, 1798) shelf mark 19 A 14086

The picture we paint of the period around 1800 acquires depth and nuance only through the popular literature generally disregarded by the elites who define the canon. Only through these works do we learn what Germans were reading while they were writing their classics – to quote the title of Walter Benjamin's 1932 radio play, *Was die Deutschen lasen, während ihre Klassiker schrieben* (What the Germans Read while Writing Their Classics). The collection of popular literature must therefore count among the core tasks of any institution committed to the history of European literature and culture in the period 1750 to 1850, including the

Herzogin Anna Amalia Bibliothek. Since the fire of 2 September 2004, when numerous works of popular fiction went up in flames, the library has been systematically buying back works in this genre and thus perpetuating a collecting tradition that began in the first half of the twentieth century.

Its first major acquisition was that of the Manuel Frey Collection in 2008, which enriched the library's holdings with 270 works by 160 popular authors of the Goethe period, the vast majority of them from Saxony and Thuringia. Amongst them were several series of works by the successful playwright and novelist Christian Heinrich Spieß, including the piece for which he is most famous, the two-volume ghost story modelled on the English Gothic novel, *Das Petermännchen: Geistergeschichte aus dem 13. Jahrhundert* (The Petermännchen: A Ghost Story from the Thirteenth Century, 1791–92) in the new emended edition of 1798 (fig. 1).

Some thirty works by Christian August Vulpius have also been added to the library's collections since 2004, amongst them various versions and editions of *Rinaldo Rinaldini*, albeit not the first. Another acquisition dating from the past fifteen years is that of nearly sixty works by the most successful writer of heroic romances of the late eighteenth century, Carl Gottlob Cramer, some of which replace those lost in the fire, while others are new. They include the tetralogy, *Leben und Meinungen, auch seltsamliche Abentheuer Erasmus Schleichers, eines reisenden Mechanikus* (Life and Opinions, also Strange Adventures, of Erasmus Schleicher, a Traveling Mechanic, 1789–1791), which is the work that turned Cramer into a best-selling author virtually overnight (fig. 2).

Fig. 2 | Carl Gottlob Cramer, Leben und Meinungen, auch seltsamliche Abentheuer Erasmus Schleichers, eines reisenden Mechanikus, Dritter Theil (Leipzig, 1790), shelf mark 19 A 13060 (3)

97

The Bernhard Stüber Collection of 230 volumes of mostly nineteenth-century German pulp fiction followed in 2012. Amongst the highlights of that acquisition were the eighty volumes of tales (1827–1829) by Heinrich Clauren and the widely read novel *Klara du Plessis und Klairant: Geschichte zweier Liebenden* (Clare du Plessis and Klairant: Tale of Two Lovers) by the best-selling author August Lafontaine in both the second (1798) and third (1802) editions (fig. 3), the library having already been able to purchase the four-volume first edition of one of Lafontaine's most successful novels, *Leben und Thaten des Freiherrn Quinctius Heymeran von Flaming* (Life and Deeds of Baron Quinctius Heymeran of Flaming, 1795–1798) in 2009.

The most recent acquisition was that of the eighty-eight works of popular German literature of the period around 1800 belonging to the collection of Dirk Sangmeister, which were accessioned in January 2022. With just a few exceptions, these are all works that the library did not possess previously and that in other libraries, too, are rare. Amongst them is *Liebe und Entsagung: Ein Gemählde hehrer Weiblichkeit und düsterer Rache*, a novel by Sophie de Choiseul-Gouffier, which was translated from French into German by Franz Rittler and published as part of the series *Erheiterungs-Bibliothek für alle Stände* in 1825. The books that once belonged to lending libraries are an especially revealing addition. One such work is the slightly dog-eared copy of *Julie Lottwer oder Der schöne Harfner in der Räuberhöhle* of 1803, which contains the ex libris label 'Buchbinderei und Leihbibliothek von Louis Eichner' in Schorndorf along with the handwritten admonition: 'Readers are kindly requested to keep books for no longer than 8 days or at the very most 14!!!'

Alongside these authors are countless others who, like their once so popular novels, have long since been consigned to oblivion, but who, thanks to the steady growth of the Herzogin Anna Amalia Bibliothek, can now be rediscovered.

CS

Fig. 3 | August Lafontaine, Klara du Plessis
und Klairant: Geschichte zweier Liebenden
(Berlin, 1801), shelf mark 234281 - A

Artistic

One centrally located, but not necessarily eye-catching, object in the Rokokosaal (Rococo Hall) is the bust of the composer Christoph Willibald Gluck, which has been standing in the same window niche next to the staircase to the first gallery for a good 200 years. While on his Grand Tour in the spring of 1775, seventeen-year-old Carl August attended a performance of Gluck's acclaimed opera *Iphigénie en Aulide* in Paris and even met the composer in person. A few days later his party visited the studio of the sculptor Jean-Antoine Houdon at the Bibliothèque royale, where Carl August ordered a copy of the bust of the composer that the artist had just finished.

A gifted portraitist, Houdon in those days was fast becoming the 'sculptor of the Enlightenment', whose works were valued as highly in Paris and St Petersburg as they were in Schwerin, Gotha and Weimar. His *Gluck*, which was the first piece in Carl August's princely collection, counts amongst the masterpieces of sculpture displayed in the Rokokosaal. From the composer's tousled hair to his pock-marked face and the coarse hatching of his attire, its finely textured surfaces cannot fail to astonish, even today. Yet, after viewing the work at the Salon de Paris of 1775, some of Houdon's contemporaries criticised the unsightly reproduction of Gluck's 'skin defects' as excessively true to life.

The bust had a contemporary pendant in Houdon's portrait of the singer Sophie Arnould in the title role of Iphigénie. Carl August acquired that work, too, while in Paris, albeit as a gift for his mother. In the course of the nineteenth century, it was forgotten altogether and only in 1999 rediscovered in the vaults of the Goethe-Nationalmuseum.

ChS

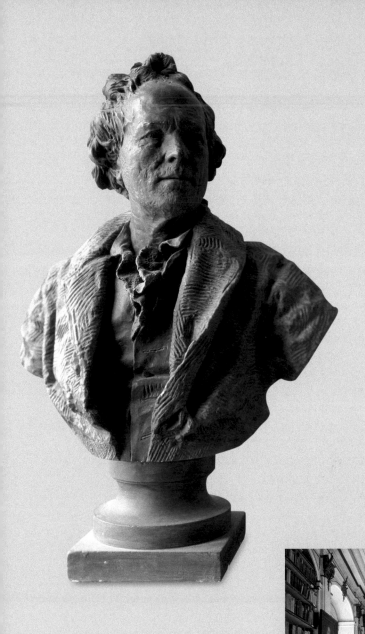

Jean-Antoine Houdon, Bust of Christoph Willibald
Gluck, plaster with greenish bronzing, 1775, inv. no.
KPI/01681

Prince Carl August acquired the bust in Paris in
August 1775 while on his Grand Tour. It is known to
have been on display in the Rokokosaal at least
since 1818.

GREAT HEADS – THE BUSTS IN THE ROKOKOSAAL

The Rokokosaal (Rococo Hall) has been one of Weimar's principal tourist attractions since the nineteenth century. It owes its overwhelming impact not just to the books, whose shelving is as practical as it is decorative, but in no small part to the paintings and busts displayed there. The library had served as an ancestral portrait gallery and had a major art collection at its disposal even in the early modern age. But it became famous primarily on account of its portraits of authors from the age of Goethe, and it was these that made the Rokokosaal such a unique showcase of Weimar Classicism.

The roots of its iconographic programme are to be found in the eighteenth-century cult of friendship, especially that of the 'Muses' belonging to Duchess Anna Amalia's own circle. She had monuments to Wieland, Goethe and Herder with Latin inscriptions by the French engraver Jean-Baptiste Gaspard d'Ansse de Villoison erected in the Tiefurter Park as early as 1782, and portrait busts of some of the key players at court were set up in the Rokokosaal at the same time. In his *Versuch einer Beschreibung sehenswürdiger Bibliotheken Teutschlands* (Attempt at a Description of Germany's Notable Libraries) of 1791, Friedrich Karl Gottlob Hirsching mentions 'the busts of now living scholars' as one of Weimar's distinguishing sights alongside the ancestral portraits.

The holdings of such likenesses grew steadily over the following decades, which also saw a change of concept that would become apparent only at Goethe's death: the self-expression of Weimar Classicism implied by the portraits of its living exponents was discontinued and replaced by a deliberate policy of posthumous memorialisation by posterity. This shift in emphasis is

evident not least in the ceremonies and festivities held in the Rokokosaal itself, which included the celebration of Goethe's fifty years of service in 1825, the interment of Schiller's mortal remains in 1826, and the centennial of Goethe's birth in 1849.

The Rokokosaal thus became a monument to Weimar Classicism long before the relevant museums were founded. By the mid-nineteenth century it was being hailed as a literary hall of fame and Walhalla, and its portraits read as a visualisation of the same national literary canon that writers such as Hermann Hettner, Joseph Hillebrand and Georg Gottfried Gervinus were even then establishing. The 'poets' rooms' installed in the Stadtschloss and the Schiller House, which opened in 1847, were also part of this development.

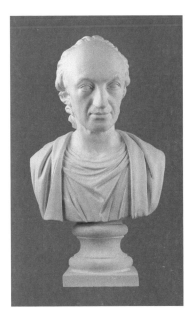

Fig. 1 | Martin Gottlieb Klauer, Christoph Martin Wieland, plaster, 1781, KSW, Museen, inv. no. KPI/O1751

The works of art on display in the Rokokosaal belong to several different periods. The 'modern' portrait collection begins with the plaster and stone busts set up in the inner oval, which are the work of the court sculptor Martin Gottlieb Klauer and date from 1782 or thereabouts. In addition to Anna Amalia, the young regent Carl August and the later classicists Wieland (fig. 1), Goethe and Herder, the ensemble also includes lesser known protagonists at court, such as the French scholars Villoison and Guillaume-Thomas François Raynal, whose stay in Weimar was comparatively brief.

Notwithstanding the numerical dominance of scholars, the leading role in the collection is played by Carl August. The life-size portrait of him by Ferdinand Jagemann installed in 1805 would henceforth be the focal point of the entire ensemble, even more so after it was moved from the north wall to the south wall in 1849. The painting gives visitors the impression of being welcomed by the prince in person and is flanked by four dynastic busts showing Anna Amalia, Carl August, Carl Friedrich and Maria Pavlovna, all of whose patronage shaped the fortunes of the Rokokosaal over many generations.

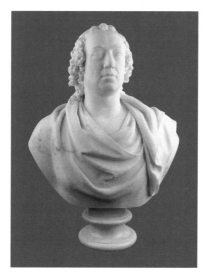

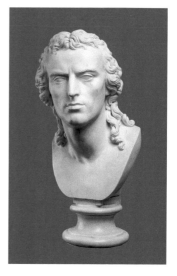

Fig. 2 | Alexander Trippel, Johann Gottfried Herder, marble, 1790, KSW, Museen, inv. no. KPI/01696

Fig. 3 | Johann Heinrich Dannecker, Friedrich Schiller, marble, 1805, KSW, Museen, inv. no. KPI/01732

At the core of the neighbouring ensemble representing the literary canon are Weimar's four great classical writers: Schiller and Goethe (on the city side) and Herder and Wieland (on the park side). The marble portraits of Herder (fig. 2) and Goethe were supplied by Alexander Trippel in Rome in the early 1790s. As important as these works are as examples of international classicism, even the subjects themselves felt they had been excessively idealised. Johann Heinrich Dannecker's 1805 bust of Schiller was added only in 1826 when Carl August succeeded in buying it from the poet's own family (fig. 3). It makes for an intriguing comparison with Johann Friedrich August Tischbein's oil painting of Schiller swathed in a distinctive red toga, which since 1860 has been located closer to the entrance (fig. 4). Deposited in the pedestals of the four busts were assorted relics and mementos of the kind that people began collecting in the mid-nineteenth century, including in the poets' own houses. One such item, if only for a brief while, was 'Schiller's skull'.

This monumentalisation reached its zenith around 1850, although the French sculptor Pierre-Jean David d'Angers' over life-size portrait of Goethe that casts the author of *Faust* as a romantic genius with wildly swept-back hair was completed even during the poet's lifetime (fig. 5). The mighty marble head was set up on a plinth inscribed with Schiller's poem 'Das

Fig. 4 | Johann Friedrich August Tischbein, Friedrich Schiller, oil on canvas, 1805, KSW, Museen, inv. no. KGe/00713

Glück' (Happiness) with Dannecker's colossal bust of Schiller as pendant. Johann Joseph Schmeller's painting of *Goethe in His Study Dictating to His Scribe* (fig. 6) served as a suitable stand-in for Goethe's study in his house on the Frauenplan, which from 1840 to 1887 was largely inaccessible.

Unlike the Walhalla that Ludwig I of Bavaria had built in 1830 to be a German hall of fame, the Rokokosaal in Weimar also had room for local celebrities and some of the great figures of world literature, such as Dante Alighieri. It also came to house relics of early modern courtly culture, such as portraits of the electors from the workshop of Lucas Cranach and the famous coat of arms of the Fruchtbringende Gesellschaft, both of which are now on the ground floor.

As over-awing as the impact still is, several works have been lost or have had to be removed. Many of the portraits on paper that once supplemented the programme of paintings and busts, for example, can no longer be permanently exhibited for conservation reasons. The blaze of 2004, moreover, resulted in the painful loss of some of the works on the second gallery.

ChS

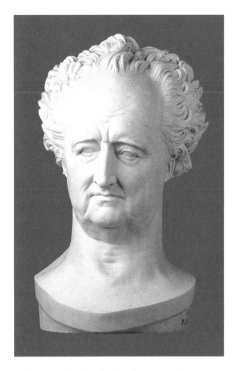

Fig. 5 | Pierre-Jean David d'Angers, Johann Wolfgang Goethe, marble, 1831, KSW, Museen, inv. no. KPl/01689

Fig. 6 | Johann Joseph Schmeller, Goethe in His Study Dictating to His Scribe, oil on canvas, 1834, KSW, Museen, inv. no. KGe/00742

Botanical

The eighteenth century saw the development in England of a new
style of garden design: the landscape garden modelled on the
harmonious ideal of the Arcadian landscapes depicted in the paint-
ings of the period. Izabela Czartoryska, a Polish princess and
patroness of the arts, encountered this style during her extensive
travels. On her return in 1791, she and her gardener, James Philip
Savage, began redesigning the park of her palace in Puławy in
the English style. She later published the theoretical and practical
knowledge she had acquired in one of the finest gardening books
of the period. In the course of its eleven chapters, the princess
describes various aspects of garden design, such as the distinctive
character of certain tree species, how to route paths, the impor-
tance of vistas and boundaries and the aesthetic interaction of
plants, monuments and garden architecture. The longest chapter is
devoted to the 'clump' as a powerfully formative component of the
landscape garden. Such a 'clump' might consist of shrubs, peren-
nials and annuals grouped according to their flowering season.
Czartoryska's sensual descriptions of her various combinations of
plants call to mind the play of light and shade, colour and form,
movement and fragrance that change constantly depending on the
weather and the time of year. The book is illustrated with twenty-
eight full-page etchings by Jan Zachariasz Frey. The Weimar copy
of the edition of 1808 is the only surviving copy in which these
are hand-coloured.

KL

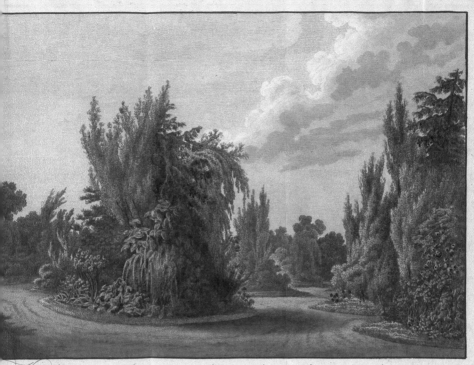

Klomby z gromadzone y sposob prowadzenia drog y sciezek

Izabela Czartoryska, Myśli Różne o Sposobie Zakładania Ogrodów / Thoughts on the Manner of Planting Gardens (Wrocław: Korn, 1808), shelf mark Th J 1 : 10 [i]

This garden book belonged to the private library of the Grand Duchess Maria Pavlovna and on her death on 23 June 1859 passed into the hands of the Großherzogliche Bibliothek (Grand Ducal Library).

THE HORTICULTURAL LIBRARIES – FROM BIODIVERSITY TO CITRUS CULTIVATION

Built to be a princely residence in the sixteenth century, the Grünes Schloss originally had a magnificent Renaissance-style garden laid out on the west side of the castle. Today, it is the east side of the building that faces onto the garden, and the garden is the late eighteenth-century Park an der Ilm, one of the earliest landscape gardens in the German-speaking world. The court at Weimar took a keen interest in botany, citrus cultivation, garden design and landscaping, and this is reflected in the library's collections. Despite the severe losses suffered as a result of the fire of 2004, its holdings still cover the whole spectrum of historical horticultural literature and are constantly being added to. To be found here alongside the Renaissance herbals, Baroque plant compendiums, botanical textbooks and plant identification books are descriptions of the flora of faraway places, catalogues of botanical gardens, treatises on garden design and architecture, manuals on the cultivation, care and use of plants, hand-drawn and printed floricultural and pomological works, garden magazines, garden plans and the sales catalogues of commercial nursery gardens. Many editions are at the same time masterpieces of botanical illustration. The collection spreads over various rooms of the library and includes a number of special collections, each with its own distinctive profile and history. Strictly speaking, it in fact comprises not just one, but several horticultural libraries as well as some outstanding single pieces.

One such item is the work known as the *Codex Kentmanus*, a sixteenth-century codex acquired in 1810 that contains many of the natural history manuscripts of the physicians Johannes and Theophil Kentmann of Saxony. It shows both father and son shar-

ing the knowledge they have amassed, some of it in Italy, on subjects ranging from medicinal herbs and plants introduced from Asia and America to the flora and fauna of the Elbe region of their native Saxony. With its c. 450 full-page illustrations of plants and animals, the *Codex Kentmanus* is one of the most wide-ranging compendiums of botanical and zoological images of the early modern age. Especially remarkable are Europe's earliest known depictions of the tulip (fig. 1) and the prickly pear, as well as imprints of more than 150 plants, which count amongst the oldest examples of the serial application of this illustration technique.

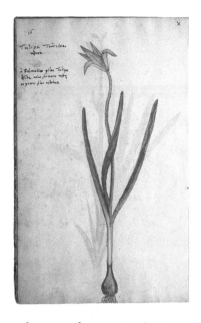

Fig. 1 | 'Tulipa turcica', water-colour from the Codex Kent-manus, c. 1549, shelf mark Fol 323

Some of the horticultural literature was kept on the second gallery above the oval oculus and hence was especially hard hit by the fire of September 2004. Amongst the works that were lost was Giovanni Battista Ferrari's study of citrus fruits, the *Hesperides sive de Malorum Aureorum Cultura et Usu Libri Quatuor*, published in Rome in 1646. That particular copy perhaps served as the source text for another priceless and unique manuscript collection that was translated into German by the dowager duchess, Charlotte Dorothea Sophie, in 1723, and is illustrated with pen and ink drawings (fig. 2). Some other valuable horticultural books were salvaged from the ashes and have since been restored, among them Christian Hesse's *Teutscher Gärtner* (German Gardener) of 1710. In

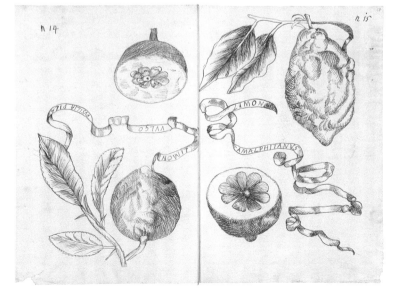

Fig. 2 | 'Lemons', pen and ink drawing from Charlotte Dorothea Sophie von Saxe-Weimar's translation of the *Hesperides* by Giovanni Battista Ferrari, 1723, shelf mark Fol 207

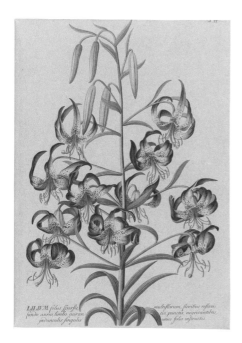

LILIUM foliis sparsis, fundo aureo, limbo aurantiaco, pedunculis singulis

multisiorum, floribus riflexis, ... punctis nigricantibus, ... annis foliis instructis

2007, wishing to fill the gaps left by the lost works, the library acquired some 260 works belonging to the Königliche Gartenbibliothek Hannover-Herrenhausen, which is home to an outstanding, mainly botanical collection. These included several magnificent works dating from the seventeenth to the nineteenth century such as Johann Wilhelm Weinmann's *Phytanthoza-Iconographia* (1737–1745), as a replacement for the one lost to the flames, and Christoph Jacob Trew's magisterial *Plantae Selectae* (1750–1790) (fig. 3). Also worthy of mention is Christian Konrad Sprengel's groundbreaking work on floral ecology, *Das entdeckte Geheimniss der Natur im Bau und in der Befruchtung der Blumen* (Nature's Secret in the Construction and Pollination of Flowers) of 1793, which is the first work to describe the role of insects in plant pollination.

Inspired by Goethe, Duke Carl August developed a particular interest in botany and garden design. The centrally positioned portrait of the prince in the Rokokosaal (Rococo Hall) shows him in front of the Roman House in the Park an der Ilm, which was landscaped in the English style largely at his instigation. Around 1800 Carl August decided to enlarge the library's horticultural collection and set aside part of the third gallery to house it. To be found here, even today, are the large-format collections of plates and the cutting-edge textbooks of the day, including Humphry Repton's *Fragments on the Theory and Practice of Landscape Gardening* of 1816 and Conrad Loddiges' monumental, twenty-volume *Botanical Cabinet* (1817–1833). Later, in 1820, Carl August founded another horticultural library specially for the ducal pleasure palace, Schloss Belvedere, which was famous for its botanical garden and collection of exotic plants even then. Around two thirds of the Belvedere's holdings, which formerly comprised ninety-

eight works in some 200 volumes, now belong to the Herzogin Anna Amalia Bibliothek. The botanist August Wilhelm Dennstedt drew up a catalogue of the c. 7,900 plant species and varieties in the Belvedere's collection, and this *Hortus Belvedereanus* was published by the Landes-Industrie-Comptoir in Weimar in 1820. This publishing house founded by Friedrich Justin Bertuch was a leading publisher of horticultural literature at the time and from 1794 to 1798 published the first German gardening magazine: Johann Volkmar Sickler's *Der Teutsche Obstgärtner* (The German Fruit Grower). This was followed by the *Allgemeine Teutsche Garten-Magazin* (General German Gardening Magazine) (fig. 4). The Comptoir's publications are now an important focus of the Herzogin Anna Amalia Bibliothek's horticultural collection, most of which, for conservation reasons, has to be kept in the underground stacks.

KL

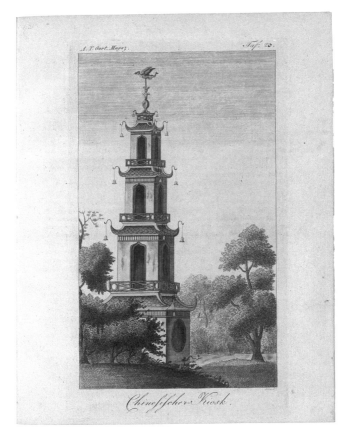

Fig. 4 | 'Chinese Kiosk', illustration from Friedrich Justin Bertuch's *Allgemeinem teutschen Garten-Magazin*, vol. 4 (1807), shelf mark ZA 1954

Musical

This printed edition of the music for six violin concertos by the musically gifted Johann Ernst IV., Duke of Saxe-Weimar dates from 1718. What makes it especially precious, however, is its famous editor, Georg Philipp Telemann. He held the office of Hof-kapellmeister at the court of the duke of Saxe-Eisenach, and presumably it was there that he became acquainted with the musical duke. Johann Ernst died at the tender age of eighteen, and this posthumous edition of his compositions is Telemann's monument to him. To judge by Telemann's foreword, the young duke must have been exceptionally gifted as well as being a first-rate music critic. He was especially fond of Italian music in the form of concertos, such as those of Arcangelo Corelli and Antonio Vivaldi. The duke probably commissioned works from both Telemann and Johann Sebastian Bach, instructing them, on the one hand, to follow Italian models and, on the other, to produce arrangements of his own compositions, as Bach obligingly did with his organ concerto BWV 592, for example.

The sheet music was found only recently amongst the charred books rescued from the ashes after the fire of 2004. Fortunately, with just a few exceptions, the sheets printed with the parts for the individual instruments were damaged only around the edge. CM

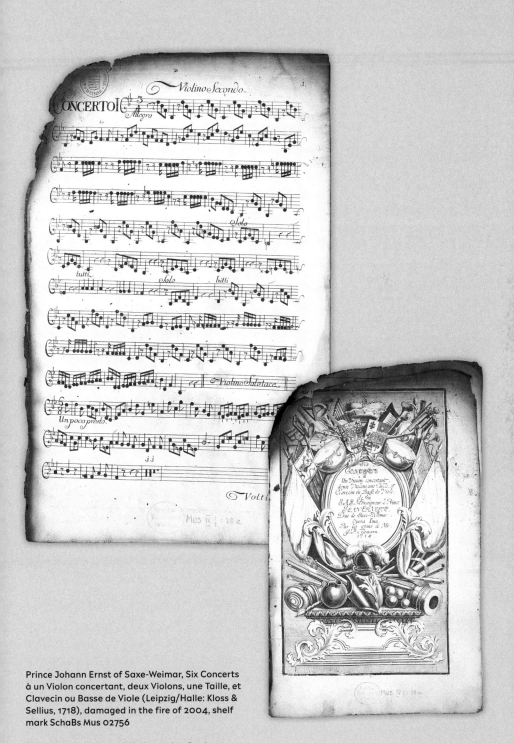

Prince Johann Ernst of Saxe-Weimar, Six Concerts à un Violon concertant, deux Violons, une Taille, et Clavecin ou Basse de Viole (Leipzig/Halle: Kloss & Sellius, 1718), damaged in the fire of 2004, shelf mark SchaBs Mus 02756

This printed sheet music belonged to Duchess Anna Amalia's own private library, which at her death on 10 April 1807 passed into the hands of the Herzogliche Bibliothek (Ducal Library).

SOUNDING RESIDENCE – THE DUCAL MUSIC ASSEMBLY

Johann Sebastian Bach undoubtedly ranks as one of Weimar's most famous musicians. His name appears on the ledgers of the court of Saxe-Weimar as early as 1703, and Duke Wilhelm Ernst would later employ him as organist and concertmaster to the court with a salary that far exceeded that of his predecessor. The story of Bach's detention and ignominious dismissal from Weimar enjoys special notoriety. In addition to the autograph of the aria *Alles mit Gott, nichts ohn' Ihn* of 1713, several copies penned in the young Bach's hand have remained in Weimar, amongst them some from his time at the Michaelis School in Lüneburg (fig. 1). While these autographs belong to the wider circle of the ducal book collection, which also contains musical objects dating back to the Middle Ages, most of the items in the Musiksammlung can be traced back to the two duchesses, Anna Amalia and Maria Pavlovna. It originally comprised some 3,000 titles, most of them musical compositions of the eighteenth and nineteenth centuries, with manuscripts accounting for some 800 and printed sheet music for 2,200 of that total. More than half those valuable objects suffered irreparable damage and loss of musical text in the fire of 2004.

The library as a whole has holdings representing a wide range of

Fig. 1 | Johann Sebastian Bach and Johann Anton Mylius, Alles mit Gott und nichts ohn' Jhn, Aria Soprano Solo è Ritornello, 1713, shelf mark Huld B 24

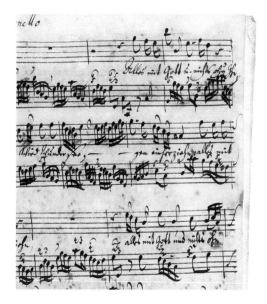

periods and currents in music history. The liturgical books and fragments dating from the Middle Ages, for example, contain plainsong written out in neumes, a precursor of the modern system of musical notation. These works came into the library's hands in part as a result of the Reformation and the ensuing secularisation of the monasteries of Erfurt. The holdings also include secular medieval manuscripts, such as Quart 564. This is a collection of songs dating from the third quarter of the fifteenth century, including some *Minnelieder* by Walther von der Vogelweide, which was acquired as part of the David Gottfried Schöber Collection in 1779.

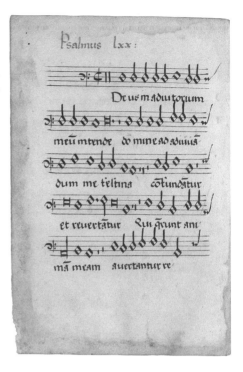

Fig. 2 | Johann Walter and Ludwig Senfl, Codex Psalmen, between 1535 and 1542, shelf mark M 8 : 55 [7][a]

Another important object in the library sheds light on the Reformation period and the turmoil surrounding the duke of Saxony's loss of his electoral status and the court's relocation to the new princely seat of Saxe-Weimar: the part books assembled under shelf mark M 8 : 55 [7] [a-b] containing compositions by Johann Walter, who has gone down in history as Protestantism's ur-cantor (fig. 2).

Several inventories list sheet music and instruments dating from the year 1662, the year when Duke Wilhelm IV died, which are no longer in the collection today, but which flesh out our picture of the ducal collection as it was then (fig. 3). The musical history of the ducal seat of Saxe-Weimar(-Eisenach) from the sixteenth to the nineteenth century, in other words, can at last be reconstructed almost in full.

Amongst the holdings from the sixteenth and seventeenth centuries are anthologies of compositions such as the *Ghirlanda de Madrigali* (1593) by Vittoria Raffaella Aleotti and the *Lustgarten Neuer Teutscher Gesänge* (Pleasure Garden of New German Songs) (1601) by Hans Leo Haßler, which in those days was extremely

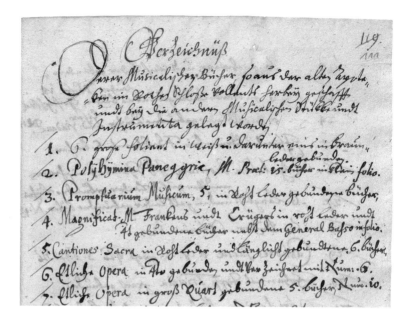

popular. In addition, there are various sacred compositions by
Orlando di Lasso and countless other, for the most part unknown,
composers such as Johannes Jeep and Sethus Calvisius. The col-
lection is further enriched by several very valuable treatises on
music theory. Dominating the collection in purely numerical terms
are the eighteenth-century holdings, amongst which the works of
two of Bach's sons, Johann Christian and Carl Philipp Emanuel,
warrant special mention – the copies and prints of the harpsichord
concertos, in particular – as well as some concertos by Arcangelo
Corelli that probably once belonged to Johann Ernst IV.

Of crucial importance to the Musiksammlung was Duchess
Anna Amalia's passion for collecting. Her love of Italian opera is
reflected in the remarkably large collection of handwritten copies
of Italian operas and oratorios. Alongside some exceptionally
valuable manuscripts, such as that of Johann Adolph Hasse's 'Dram-
ma per musica', *Ezio*, this includes Niccolò Jommelli's *L'Olimpiade*,
Simon Mayr's *I misteri eleusini*, and Giovanni Paisiello's *Socrate
immaginario*. Joseph Haydn's *Isola imaginata*, with what are prob-
ably the composer's own annotations, as well as more upbeat
works such as Giuseppe Sarti's *Fra I due litiganti il terzo gode* and
Guglielmi's *La bella pescatrice* round off the collection. Also pre-
served here are some highly prized scores by Christoph Willibald
Gluck, some of them in his own hand. The music of the Prussian

royal court also made its way to Weimar in the compositions of Johann Friedrich Reichardt and Friedrich Heinrich Himmel, as did the countless lieder of the Stuttgart composer Johann Rudolf Zumsteeg and the harpist-cum-composer Friederike Pallas. The library also has in its possession some very important handwritten copies of Carl Maria von Weber's piano sonata op. 24. Another focus are French works for the stage by composers such as François-Adrien Boieldieu, Étienne Méhul and André-Ernest-Modeste Grétry. Maria Pavlovna, daughter of the Russian Tsar Paul I, arrived in Weimar as the new Duchess of Saxe-Weimar-Eisenach with numerous works of chamber music and piano pieces in her baggage, some of which tell of the fascinating rapprochement of Italian music and the Russian Orthodox Church. Indeed, many of the great Italian composers of the second half of the eighteenth century were in the service of the Russian ruling dynasty. The composition *Otče naš* (Our Father) and several other choral compositions by Galuppi's pupil Dmitry Bortniansky attest to the strange hybrid style to which these ties gave rise. Still more pieces, some of them very rare, from St Petersburg and Moscow by composers such as Jean-Baptiste Cardon, Ignác Held, the unknown guitarist Aléxis Achanin and the composing virtuoso pianist Maria Szymanowska also belong to this category. The musical life of Weimar, and with it the library's music collection, was to enjoy a second great flowering under Johann Nepomuk Hummel. It was from Hummel, a former pupil of Wolfgang Amadeus Mozart, that the library acquired an authenticated and hence extremely precious autograph: that of Mozart's Piano Concerto in B-flat major, KV 450 (figs. 4 and 5).

The library also houses music of the Paris concert and salon scene around the composers Sigismund Thalberg, Ignaz Pleyel, Friedrich

117

Kalkbrenner as well as Franz Liszt. The latter was a very influential figure for the musical life of Weimar. As head chapel master and the founder of the orchestra school that preceded today's Hochschule für Musik Franz Liszt Weimar, he taught innumerable boys and girls, including the Russian composer and pianist Martha von Sabinin and the Irish pianist Bettina Walker. He supported young artists and was instrumental in the success of Richard Wagner. His patronage of Hector Berlioz and performance of Berlioz's works also brought a whiff of Paris to Weimar, as evidenced by the score of the orchestral overture *Les francs juges* (fig. 6). The acquisition of the Liszt Library in the twentieth century endowed the Weimar Musiksammlung with the composer's own private holdings, even if their allocation to the Herzogliche Bibliothek (Ducal Library) is not always unambiguous. It is with Liszt and the end of the Duchy of Saxe-Weimar-Eisenach that a large chapter of the Weimar music history as well as the history of the Herzogliche Musiksammlung end. The library has nevertheless remained an active collector of music to this day, and through its acquisitions of still more collections and musicological literature offers a wealth of possibilities for anyone wishing work on music-related topics and study Weimar's musical heritage.

CM

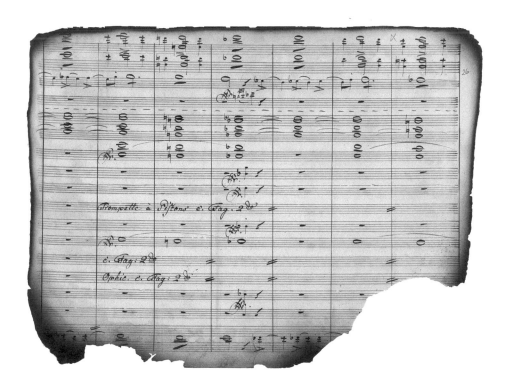

Fig. 6 | Hector Berlioz, overture to the opera, *Les francs juges*, copy, c. 1830, damaged in the fire of 2004, shelf mark SchaBs Mus Hs 00118

Strategic

The Militärbibliothek (Military Library) possesses eleven model fortresses. They were created in 1827–1828 to supplement a manual on the art of fortification by Prussian officer Alexander von Zastrow, several editions of which were published between 1828 and 1854. The models show reliefs of the various fortification systems – which are called *Maniere* (manners) – and hence the principal styles of fortress-building. Each model presents the layout and profile of the ideal, geometrically designed fortress of a given style. Measuring 420 millimetres wide, 344 millimetres deep and 26 millimetres high, they are made of plaster and are kept in an old wine case, which was not originally part of the set. They served as teaching materials for budding military engineers.

The demonstration of the basic principles of fortification starts with the *Manier der Italiener* (Italian manner) that emerged in the early modern age. Its key feature are the bastions built into the walls. How this bastion fort then evolved is evident from the *Maniere* of the seventeenth and eighteenth centuries by Daniel Specklin, the French military engineer Sébastien Le Prestre de Vauban and his successor Louis de Cormontaigne. Examples of the Dutch style that arose during the sixteenth-century Dutch War of Independence against Spain are provided by the *Manier* of Adam Freitag and the *Iste Manier* of Menno van Coehoorn. The eighteenth century saw the development of star forts that had no bastions or curtain walls at all, as evidenced by the fortification systems of Johann Heinrich von Landsberg and Marc René de Montalembert.

AB

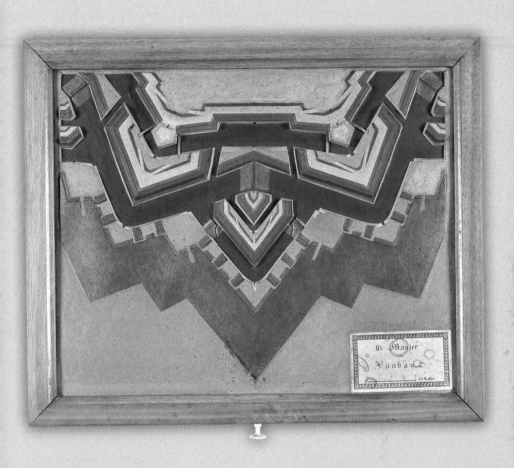

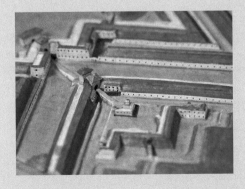

Model Fortresses after Heinrich Adolf von Zastrow,
c. 1828, shelf mark Kt 800 - 33

The model fortresses entered the Großherzogliche
Sammlung (Grand Ducal Collection) in c. 1830.

MILITARY LIBRARY –
THE SCIENCE OF WARFARE

The Militärbibliothek (Military Library) was amassed by the dukes and librarians of Weimar between 1630 and 1930. While almost all German military libraries were destroyed or severely depleted during the two world wars, the Weimar collection has to a large extent been preserved. By the mid-nineteenth century it comprised 7,500 maps, 6,000 books, 400 manuscripts, assorted globes and model fortresses. It enjoyed its highest growth rate during the period of the French Revolution and the Napoleonic Wars between 1789 and 1815 (fig. 1), when it developed into a universal storehouse of knowledge. It grew beyond military literature in the narrower sense and became encyclopaedic in scope.

The oldest holdings date from the Thirty Years' War, specifically from c. 1630 when Duke Wilhelm IV assembled a collection of books on artillery and fortress-building at his castle, Schloss Wilhelmsburg in Weimar. Amongst them were several volumes from the library of the Elector of Bavaria in Munich that fell to him as war booty after he fought on the side of the Swedes in the Battle of Lützen in 1632. These included Franz Helm's magnificent *Büchsenmeister- und Feuerwerkbuch* (Gunsmith and Fireworks Book), which is a sixteenth-century artillery manual complete with gunpowder recipes, loading instructions and advice on the precise installation of various gun types (fig. 2). Wilhelm's successors enlarged the collection as part of their own private library.

The dukes of Weimar traditionally had close ties to the Prus-

Fig. 1 | Stamp seal of the Weimar Militärbibliothek (Military Library)

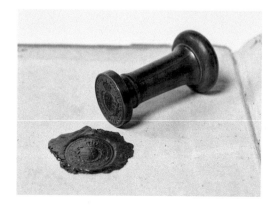

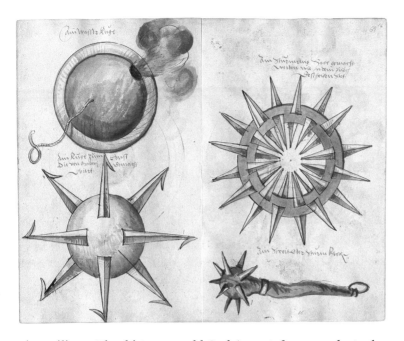

Fig. 2 | Franz Helm, *Büchsenmeister- und Feuerwerkbuch*, 1556/1566, shelf mark Fol 330

sian military. The thirty-year-old Carl August, for example, took command of Von Rohr's Old Prussian regiment of cuirassiers in Aschersleben in December 1787. This afforded him access to the libraries of the Prussian regiment and its officers, prompting him to consolidate and enlarge his own holdings of historical military literature and to merge them with the existing map collection. Carl August also did much to promote the development of military cartography during this period and he and the Duke of Gotha commissioned military surveyors and engineers to produce ordnance survey maps of their domains. Friedrich Justin Bertuch and his publishing house, the Landes-Industrie-Comptoir, had specialised in the production of maps, atlases and globes since 1791, and his *Topographisch-militärische Karte* (Topographical Military Map) of Central Europe of 1807 became a much-sought-after resource. By 1800, therefore, Weimar had become one of Germany's most important map-making centres.

While the central German principalities were relatively unimportant, militarily speaking, Carl August was well aware of the geostrategic importance of Thuringia during the War of the First Coalition from 1792 to 1797. The Peace of Basel concluded between France and Prussia in 1795 defined a demarcation line that would guarantee the neutrality of the northern German states in

the ongoing conflict between France and Austria, should they elect to join the treaty. The Saxon duchies initially left their contingents where they were, i.e. with Austria, but in 1796 decided to sign the treaty of neutrality after all. The line demarcating the French sphere of influence thereafter followed Thuringia's southern border, and it was during this period that Carl August developed a plan envisaging a *Defens-Linie* (line of defence) for Thuringia along the ancient boundary path called the Rennsteig.

The year 1806 saw another outbreak of war between France and Prussia. This time the French invaded Thuringia. Two weeks before the Battle of Jena and Auerstedt, Duke Carl August had some important maps sent to General Ernst von Rüchel, who was commanding the Prussian reserves in the Eisenach/Gotha region. After the battle on 14 October 1806, the French army repeatedly requisitioned parts of Weimar map collection, taking some 700 maps that were subsequently lost in the course of various campaigns. The Militärbibliothek was nevertheless kept alive by those Prussian officers who after the defeat of 1806 entered into the service of the Weimar court, amongst them August Rühle von Lilienstern and Karl Freiherr von Müffling (fig. 3).

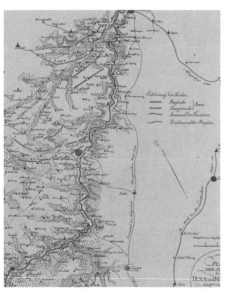

The books and maps belonging to the Militärbibliothek were kept under the dome of the library tower and organised in twelve sections from A to M (fig. 4). Sections A and B housed the literature on fortifications on the one hand and artillery on the other. The underlying dialectic, in other words, was that between defence and attack, fortification and destruction, order and violence. Section C of the Militärbibliothek contained manuscripts of relevance to military history, which would later include the military estate of Duke Carl August himself. Sections D to F were devoted to military history and the history of warfare, in which depictions

Fig. 3 | Plan of the Battle of Jena and Auerstedt with troop positions drawn onto it, after 1805, shelf mark Kt 625 - 3 E

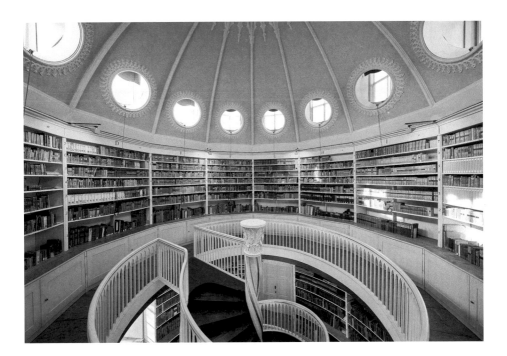

Fig. 4 | Dome of the library with the Militärbibliothek

of the Seven Years' War, the Revolutionary Wars and Napoleon's campaigns were accorded a special place. Pictures, drawings and atlases were kept in Section G, newspapers and periodicals in Sections H and I, writings on tactics and adjunct military sciences such as mathematics, geography, topography, logistics, medicine and metrology in K to M, and, finally, the encyclopaedias and dictionaries in Section M.

The collection is now closed, although works of historical and critical relevance are sometimes added, especially those that shed light on how enmeshed the worlds of soldiering and of poetry and the pursuit of knowledge once were. One significant acquisition of 2020, for example, was a book gifted to the officer Philipp Wilhelm Ludwig Gauby of Weimar by no less a figure than Goethe himself and bearing the poet's own handwritten dedication of 3 April 1815. That was the day that the Weimar line infantry battalion went to war against Napoleon as part of the Prussian army. The book that Goethe gave Gauby to read while in the field, and extolled in his letter of recommendation, was his own epic poem, *Hermann und Dorothea*.

AB

Global

The Europeans' cartographic image of the world had to be revised following the discovery of America. Starting in 1515 the cosmographer Johannes Schöner and his workshop produced a range of variously sized terrestrial globes that showed the continent's dimensions and recorded the name America. One famous example of these globes has been preserved at the Herzogin Anna Amalia Bibliothek (Duchess Anna Amalia Library) in Weimar, while its no less well-known twin is housed in the Historisches Museum in Frankfurt am Main. Schöner's terrestrial globe first went to the court of Johann Friedrich I, Elector of Saxony, in Wittenberg and in the decades thereafter was taken to Jena, via Weimar, together with the *Bibliotheca Electoralis*. In October 1821, at a time when Goethe was 'chief inspector of all the ducal institutes of science and art', the library in Jena was visited by Carl August, Grand Duke of Saxe-Weimar-Eisenach, who had the globe transferred to the newly founded Militärbibliothek (Military Library) in Weimar. No less a figure than Alexander von Humboldt singled out Schöner's globe for mention as an exceptional cartographic object to be admired in Weimar in his multivolume *Kosmos* of 1847. The globe was to travel again much later, when, in the mid-1960s, it was removed from the vaults of what was then the Nationale Forschungs- und Gedenkstätten der Klassischen deutschen Literatur (National Research and Memorial Sites of Classical German Literature) in Weimar, and taken to the Mathematisch-Physikalische Salon in Dresden. It did not return to the library in Weimar until 2007. Now, in the twenty-first century, the virtual presentation of 3-D objects has opened up new perspectives for Schöner's representation of the earth and so led to a renaissance of these historical world models – in the virtual sphere.

AC

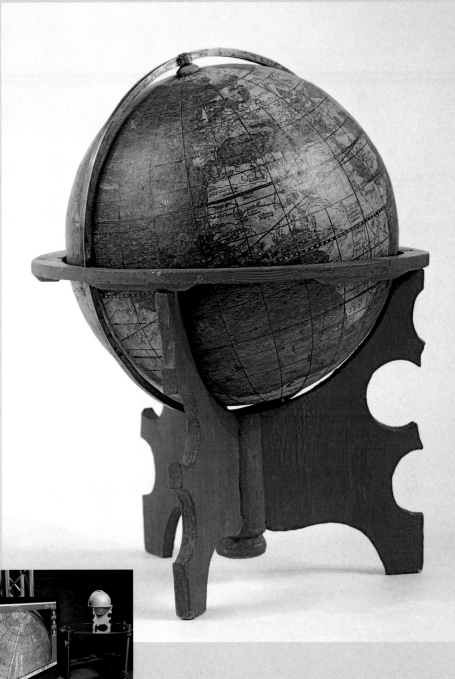

Terrestrial Globe, made by Johannes Schöner,
1515, shelf mark Kt 800-1

In 1821, the globe became part of Grand Duke Carl
August's Militärbibliothek (Military Library), which
in 1825 was officially handed over to the Großher-
zogliche Bibliothek (Grand Ducal Library).

MAPS AND GLOBES –
THE DISCOVERY OF THE WORLD

By the time Alexander von Humboldt entered his name in the *Verzeichniß der Fremden der Weimarer Bibliothek* (the library visitors' book) on 12 December 1826 (fig. 1), his first face-to-face encounter with the two-decades-older Goethe lay thirty years in the past. Back then, the two kindred spirits had eagerly launched into an enthusiastic exchange of thoughts and ideas. Humboldt's presence, an excited Goethe told Schiller in 1797, had roused his works on natural history 'from their winter sleep'. Humboldt, for his part, writing to Caroline von Wolzogen in 1806, acknowledged that 'Goethe's views of nature' had raised him up, 'as if equipping him with new organs'.

Humboldt's particular interest was in the textual and cartographic sources recording the great discoveries of the early modern age. Hence his mention of some of the treasures of the Kartensammlung (Map Collection) in his *Examen critique de l'histoire de la géographie du nouveau continent et des progrès de l'astronomie nautique aux quinzième et seizième siècles* (Critical Investigations on the Historical Development of a Geographical Knowledge of the New World and the Progress of Nautical Astronomy in the Fifteenth and Sixteenth Century), the German translation of which was published in 1836. 'Five geographical monuments' – three maps and two globes – are accorded special mention.

The oldest map in the collection merited a particularly detailed description: a very precious 'Portolan map' used for navigation at sea (fig. 2) attributed to the Italian maritime cartographer Conte di Ottomano Freducci. Whereas Humboldt read the year as 1424,

we now know that it almost certainly dates from the period 1481 to 1499.

It is drawn on parchment and at its centre shows the Mediterranean with all its islands and major ports. The line grid that typically serves as a navigational aid for seafarers on such charts is clearly visible, even if its original colours can barely be made out. Indeed, the chart's general state of preservation impairs its legibility and many of its details are more readily recognisable on a nineteenth-century copy of it that has also survived (fig. 3). Some of the vaguely discernible lines of writing, for example, refer to a Baltic legend that is otherwise found only on Catalan maps. After a brief description of the sea, these tell of the six months in which the Baltic Sea was encased in ice so thick that ox carts could be driven over it and wooden huts built on top of it. Humboldt also describes some of the '*Zierrathen*' (embellishments) illustrating the map: two sultans, the Russian ruler and Saint Catherine's Monastery in the Sinai Desert. Genoa and Venice are given prominence by two *vedute* crowned by flags bearing the republics' respective coats of arms.

Fig. 2 | Portolan map by Conte di Ottomano Freducci (attributed), 1481–1499, shelf mark Kt 400 - 246 E Ms

What also caught Humboldt's eye were the islands of Antilia, Satanazes and the Saint Brendan Islands in the eastern Atlantic. These are phantom islands, which were included in old maps and charts on the basis of historical accounts, but probably never existed. The Saint Brendan Islands can be traced back to the tenth-century *Navigatio Sancti Brendani*, which describes the travels of the Irish abbot Brendan von Clonfert and his twelve companions in the years 564 to 573. On their voyages across the Atlantic they see battling sea monsters, discover an array of islands and eventually land at their destination, the promised Land of the Saints. Antilia was also called the 'Island of the Seven Cities' on account of the seven Spanish bishops

Fig. 3 | Sultan and Red Sea, detail of a drawing after the Portolan map, 19th cent., shelf mark Kt 400 - 249 E Ms

and their followers, who, having fled the Moorish conquerors of the Iberian Peninsula, supposedly established seven new parishes on the island.

Humboldt's *Examen critique* also discusses two very important maps that are likewise drawn on parchment (fig. 4). These are large-format maps of the known world that Diego Ribero, cartographer to Emperor Charles V, charted after the '*Padrón Real*' in 1527 and 1529. The *Padrón Real* was the top-secret map onto which all the new discoveries reported by seafarers were entered and which was kept under lock and key in Seville. Humboldt's description of the geographical monuments held by 'this richly endowed public collection, commonly known as the Militärbibliothek' ends with his mention of the two terrestrial globes by Johannes Schöner of 1515 and 1533/34.

Duke Carl August's expansion of the Militärbibliothek greatly added to the collection of maps and charts that is known to have existed in Weimar even in the seventeenth century. As Carl August, like his predecessors before him, had close ties to the Prussian military, the practical and strategic value of maps and charts on the battlefield was also a factor behind his substantial acquisitions. At his death in 1828, the collection comprised not just books and manuscripts, but also 6,000 maps, twenty-five globes and eleven model fortresses, which have remained the core of the Weimar map collection to this day (fig. 5). One geographical focus is on maps of Europe and Germany, another on world maps, nautical and astronomical charts, maps for military manoeuvres, street maps of cities and fortification plans. Among the hand-drawn sheets are military plans and sketches as well as maps of interest to re-

gional historians. Several editions of Ptolemy's *Geographia* and a rare, magnificently illuminated German edition of Abraham Ortelius' *Theatrum Orbis Terrarum*, published by Johann Koler in Nuremberg in 1572 also warrant mention, as does the outstanding atlas collection (fig. 6).

The recently acquired collection of the famous historian of cartography, Jürgen Espenhorst, added a further 1,700 atlases and 1,100 maps from the period 1800 to 1970, and with them a unique record of how modern cartography developed. The adjunct collections feature various 'miracle maps' – sets of sliding maps in Bakelite frames – as well as cloth maps and aerial maps charted for aviation and aerial warfare. The atlases are all documented in the atlas database, AtlasBase, which provides an excellent basis from which to explore the new acquisitions listed in the library catalogue.

ACK

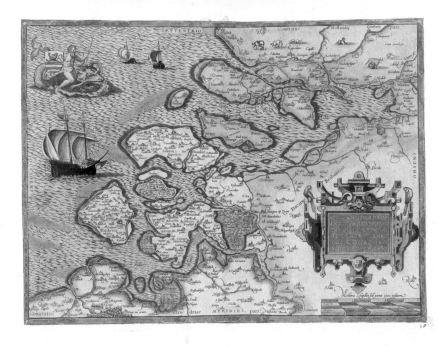

Fig. 6 | Zealand, detail from Abraham Ortelius's *Theatrum Orbis Terrarum* (Nuremberg, 1572), shelf mark Kt 700 - 42 L

Universal

Goethe's translation of the *Life of Benvenuto Cellini* is a high-water
mark of Weimar Classicism. He translated the autobiography of
the Florentine goldsmith and sculptor for Schiller's literary jour-
nal, *Die Horen*, and then published it as a book in 1803. Goethe's
copy of the first edition of the Italian original affords us a glimpse
of his working method. The faint pencil lines indicate where the
excerpts for the *Horen* begin and end, and here and there he has
added some dates and names. Pasted into the front of the book is
a Medici family tree that Goethe himself drew and had printed in
the book edition of his translation. Slipped into the back of the
volume is a table calculating the amount of text that he supplied
to Schiller. The infamy attached to Cellini's colourful and lively
account of his life stems from his descriptions of the murders he
committed and the ghosts he conjured. Presumably that is why it
did not go to print until 1728, more than 150 years after the artist's
death, and then only under a fake imprint. Goethe saw in Cellini
a 'representative of his century'. His translation, moreover, was his
first serious engagement with autobiography, a genre that he him-
self would later try his hand at in works such as *Aus meinem Leben:
Dichtung und Wahrheit* (*Poetry and Truth*). The name entered on
the title page of Cellini's work proves that this copy once belonged
to the British artist, Charles Gore, who spent his final years in
Weimar. The three small pencil drawings in it were there before
the book came into Goethe's possession and are perhaps the work
of Gore's daughter Emilia.

SH | UT

VITA

DI

BENVENUTO CELLINI

OREFICE E SCULTORE FIORENTINO,

DA LUI MEDESIMO SCRITTA,

Nella quale molte curiose particolarità si toccano appartenenti alle Arti ed all'Istoria del suo tempo, tratta da un'ottimo manoscritto, e

DEDICATA

ALL'ECCELLENZA DI MYLORD

RICCARDO BOYLE

Conte di Burlington, e Cork, Visconte di Dungarvon, Barone di Clifford, e di Lansborough, Baron Boyle di Brog Hill, Lord Tesoriere d'Irlanda, Lord Luogotenente di Westriding in Yorkshire, siccome della Città di York, e Cavaliere della Giarrettiera.

IN COLONIA
Per Pietro Martello.

Vita di Benvenuto Cellini orefice e scultore
Fiorentino, da lui medesimo scritta (Life of
Benvenuto Cellini, Goldsmith and Sculptor of
Florence, in His Own Words) (Cologne [Naples]:
Martello, 1728), copy from Goethe's private
library, shelf mark Ruppert 54

In the Goethe-Nationalmuseum since 1886.

GOETHE'S LIBRARY – FROM A CLASSICIST'S WORKSHOP

Johann Wolfgang Goethe's library is perhaps the most important private book collection of any German writer around 1800, in part because it is one of only a few author's libraries of that period to have survived. The practice of selling or auctioning off a person's books following their death continued until well into the nineteenth century. Goethe's heirs, however, held onto his books for several decades until his last living grandson, Walther von Goethe, bequeathed both the library itself and the other collections to the Grand Duchy of Saxe-Weimar-Eisenach. Traditionally, Goethe's library was kept in an otherwise unassuming room with plain, pale-grey shelves adjoining his study (fig. 1). The book collection was not accessible during Goethe's lifetime as it was located in the 'private' part of the house on the Frauenplan, to which only family members and those in the service of the duke had access.

The 7,250 volumes still preserved reflect Goethe's wide-ranging interests. While literature in German and other languages and works on archaeology, art history and the natural sciences clearly dominate, there are works representing almost every other branch of knowledge of this period – from economics and jurisprudence to travelogues and even cookbooks. For Goethe books were one of the tools of his trade and crucial to both his scientific experiments and his extensive art collections.

A few of the books in the library once belonged to other family members, from Goethe's grandparents to his grandchildren, sometimes handed down within the family. However, almost half of the collection can be traced back to outside sources, meaning that they were sent to him by authors, publishers, translators and others who already had some connection to Goethe or wanted to attract his no-

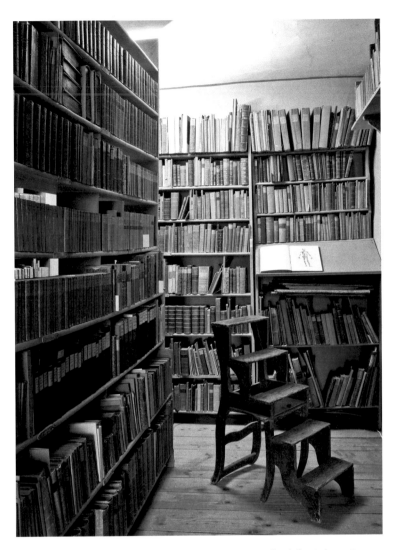

Fig. 1 | The library in the Goethe House on the Frauenplan

tice. Amongst them were famous names as Heinrich Heine, Georg Wilhelm Friedrich Hegel and, of course, Friedrich Schiller, but also some as yet unknown authors and scientists at the start of their career, eagerly hoping for Goethe's support. Amongst the few to elicit a response was the Scottish essayist Thomas Carlyle and the young Johann Peter Eckermann, who in 1821 sent Goethe his first volume of poetry and would later become one of his closest assistants.

Goethe the book buyer was not one to judge a book by its covers, and almost all the finely tooled deluxe editions in his collection are known to have come to him as gifts. His luxury edition

Fig. 2 | Binding by René Simier, bookbinder to the king, of a French edition of *Faust* of 1828, gifted to Goethe, shelf mark Ruppert 1826

of a French translation of *Faust*, for example, was sent to him by the publisher Charles Motte. The leather binding is the work of René Simier, bookbinder to the king, and inserted into it is a medal bearing Goethe's portrait (fig. 2). Another attraction of this edition, besides the drama itself, are the artfully done lithographs by Eugène Delacroix (fig. 3).

Goethe's library as it is today comes from his estate and comprises some 90 per cent of the works that were in his possession at his death. During the poet's own lifetime, however, it was a much more a protean entity. Hundreds of volumes came and went and are no longer on record at all. Around three quarters of the books date from the period after 1800 and almost as many are printed in German. French and Latin account for around one tenth each, while the remainder is in miscellaneous languages. Some of Goethe's books are probably still in circulation on the second-hand book market, unbeknownst to us. Only very rarely did he lay claim to them by appending his name or monogram; the ex libris label now to be found in approx. Forty per cent of the volumes was applied only after his death (fig. 4).

The exact content of the bookshelves was for a long time undocumented. According to the first list to have survived, dating from 1788, Goethe was slow to enlist professional help. In fact, it was not until 1822 that Friedrich Theodor Kräuter, a trained librarian at the Herzogliche Bibliothek (Ducal Library), began cataloguing Goethe's book collection and assiduously listing all the books that were being sent to the poet (fig. 5). Kräuter's work was all the more necessary given that Goethe, in his old age, had surrounded himself with assistants who also had to know their way around his book collection. According to Goethe's will, Kräuter was to re-

Fig. 3 | Illustration by Eugène Delacroix in the French edition of *Faust* of 1828

main in charge of not just his library, but also his manuscripts and his collections of art and natural specimens. The librarian willingly complied – at least until Goethe's grandchildren drove him away in 1845.

The books have been visible to the public ever since the opening of the Goethe Nationalmuseum in 1886. There have been several attempts to catalogue the library over the decades, one of which even had the support of Baldur von Schirach, the leader of the Hitler Youth who grew up in Weimar. While some failed on account of the magnitude of the task, others were thwarted by external factors such as galloping inflation, the economic turmoil following the Crash of 1929, and the Second World War. Not until 1958 did retired librarian Hans Ruppert publish the first printed catalogue. Since 2014, Goethe's library and the books he borrowed from the Ducal Library have been the subject of a research project by the Forschungsverbund Marbach Weimar Wolfenbüttel. One result of that project is the *Goethe Bibliothek Online*, a digital catalogue that can be viewed via the electronic catalogue of the Herzogin Anna Amalia Bibliothek (Duchess Anna Amalia Library). The books in Goethe's library are to be returned to their original location at the Goethe House on the Frauenplan once its planned renovation has been completed.

SH | UT

Fig. 4 | Ex libris label in a volume from Goethe's library

Fig. 5 | Title page of the handwritten catalogue of Goethe's book collection drawn up by Friedrich Theodor Kräuter, 1822–1839, no shelf mark

Philosophical

Ralph Waldo Emerson was an American philosopher, moralist, writer and outspoken opponent of slavery. He espoused a brand of individualism that drew on Puritanism, Platonism, German idealism, English romanticism and Indian philosophy. Friedrich Nietzsche esteemed him as the 'most thoughtful author' of the nineteenth century.

Emerson's *Versuche* is the most heavily annotated book in Nietzsche's library and both the title page and the inside of the covers contain draft texts by Nietzsche that probably date from the autumn of 1881; they certainly point in the direction of *Also sprach Zarathustra*, the first part of which was published in 1883.

Nietzsche clearly felt very much at home in this book with its grey, cut-flush binding. It accompanied him from 1862, when he was a pupil at the Pforta school, right up to his last period of sanity in 1888: 'Emerson with his essays has been a good friend to me and cheered me in dark times: he has so much scepticism, so many "possibilities" in him ... I loved listening to him even as a boy.' There are references to Emerson in several of Nietzsche's works from *Unzeitgemässige Betrachtungen* (*Untimely Meditations*) of 1874 to *Ecce Homo* of 1888.

EvWM

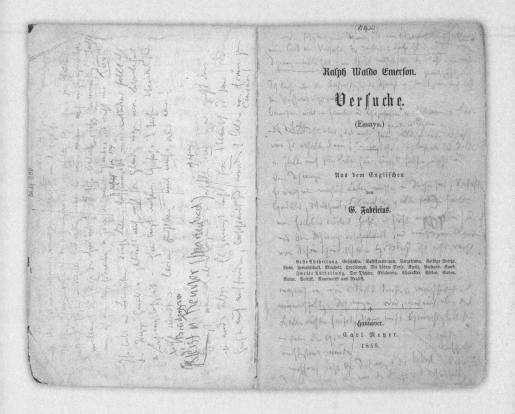

Emerson, Ralph Waldo, Versuche (Essays), from the
English by G. Fabricius (Hannover: Meyer, 1858),
copy from Nietzsche's private library, shelf mark
C 701

This book from Friedrich Nietzsche's private library
was accessioned by what was then the Thürin-
gische Landesbibliothek in 1955.

NIETZSCHE'S LIBRARY – THINKING AND WORKING WITH BOOKS

The library belonging to the estate of the philosopher Friedrich Nietzsche at the Herzogin Anna Amalia Bibliothek (Duchess Anna Amalia Library) is researched as is almost no other (fig. 1). It is now part of the library's Nietzsche Collections, which also comprise the c. 6,000 volumes belonging to the library of the former Nietzsche-Archiv in Weimar as well as a collection of Nietzschean literature that was begun in 1955 and now numbers over 8,000 volumes. Nietzsche's own library extending from shelf marks C1 to C 775 constitutes a largely self-contained subset of these collections. The philosopher's own copies of his works along with several galley proofs, some of them marked with his handwritten emendations and corrections, are kept with the holdings of the former Nietzsche-Archiv. A further 133 books and other printed matter that likewise belonged to Nietzsche's library are now housed in Weimar's Goethe- und Schiller-Archiv, as is almost all the sheet music that he possessed.

Some 1,400 volumes from Nietzsche's library have been preserved. After his breakdown in Turin in early January 1889, the philosopher's mother, Franziska, and his sister, Elisabeth, gathered up all the books that he had kept in several different places and took them first to Naumburg and then, in 1896, to the Weimar Nietzsche-Archiv (fig. 2). The books were moved again when the archive was dispersed after the Second World War: in 1950 to the Goethe- und Schiller-Archiv and then, in 1955, to what was then the Thüringische Landesbibliothek. They

Fig. 1 | Portrait photograph of Friedrich Nietzsche, 1882, KSW, Goethe- und Schiller-Archiv 101/18

Fig. 2 | The living room on the first floor of the Nietzsche-Archiv in Weimar, c. 1900–1903, KSW, Goethe- und Schiller-Archiv 101622 a

were kept in various rooms of the Weimar Stadtschloss until 2005, when they were transferred to the modern stacks installed underneath the Platz der Demokratie.

Nietzsche's library does not come across as a systematically collected scholarly library; on the contrary, its fragmentary character attests to the peripatetic existence of its owner, who even during his lifetime lost many of his books in a whole host of ways. Especially striking is the somewhat paltry selection of belles-lettres in his library, and we know from Elisabeth Förster-Nietzsche that he gave away many of his books belonging to that category. Nietzsche was in any case famous for carrying whole stacks of books to second-hand book dealers, especially after he relinquished his teaching post in Basel and spent the next ten years as an itinerant writer and philosopher. That a relatively large number of books from both his schooldays and his time as a student of philology has survived is thanks to his sister, who took her brother's books into her safekeeping even in their youth. It was she who in 1881 saved Nietzsche's Basel library, some of whose books contained evidence of his philological work, and who in 1886, having thwarted its sale, sent it to her mother in Naumburg. Elisabeth was also among the first to grasp how closely enmeshed her brother's reading and writing had been, and it was she who in 1896 had his library catalogued by one Rudolf Steiner, who in

those days was assisting with the Weimar edition of Goethe's works (also known as the 'Sophie edition' after reigning Grand Duchess) at the Goethe- und Schiller-Archiv. Steiner's handwritten catalogue is now housed in the same archive. It is organised according to subject and provides information on dedications, annotations and markings as well as listing Nietzsche's personal copies of his own works. The Nietzsche-Archiv was reorganised and recatalogued – this time with a card catalogue – in 1932 in preparation for a new critical edition of his works that was to remain unfinished. Max Oehler's printed catalogue of 1942 builds on that earlier attempt.

The largest subset of Nietzsche's books to have survived comprises literature on Classical Antiquity. Another relatively large group is that made up of works on modern philosophy. Other subjects, such as religion, education, the natural sciences, history, geography, ethnography, jurisprudence, aesthetics, the history of art and culture, literature and the history of literature are also represented, though often only sparingly.

Fig. 3 | Aeschylus, Choephori (Giessen, 1860), shelf mark C 4

un grand criminel. Goûtera-t-il de bien vives jouissances
esthétiques? La délicatesse morale et la délicatesse esthé-
tique se touchent en général d'assez près : il est peu pro-
bable que l'être incapable de remords, et à qui échappent
ainsi toutes les nuances de la vie morale, soit apte à
saisir les nuances du beau, à éprouver dans toutes ses
variétés et ses vivacités l'émotion esthétique[1]. La capa-
cité d'une sincère admiration pour le beau correspond

Numerous books from Nietzsche's library contain evidence of
his reading habits. These range from uncut pages, indicating that
the book was almost certainly never read, to scattered markings
and underscorings, dog-eared pages, doodles and marginalia rang-
ing from the isolated to the intense, annotations, translations and
précis and even the occasional perforation (figs. 3 and 4). By the
same token, there are books containing dedications to Nietzsche
that tell of the friendly relations he enjoyed with his contemporaries.

The close-knit character of Nietzsche's library was spotted
early on and prompted Mazzino Montinari, an Italian scholar of
German literature and editor of the *Kritische Gesamtausgabe*
(critical edition) of the philosopher's complete works and letters,
to initiate a working group that in the 1990s produced a new cat-
alogue of the library, including all the minutiae of his markings
and annotations. This 700-page tome was published in 2003 as
Nietzsches persönliche Bibliothek (Nietzsche's Personal Library).
1996 and 1997 saw the library recorded on microfilm and in 2015
work began on its systematic digitalisation. The Herzogin Anna
Amalia Bibliothek has at its disposal a subject catalogue of its
Nietzsche collection, of which Nietzsche's own library forms a part.
Further work on Nietzsche's library is being done under the aus-
pices of *Nietzsches Bibliothek: Digitale Edition und philosophischer
Kommentar*, which is a joint project by the Department of Philos-
ophy at the Albert Ludwig University of Freiburg and the Institut
des textes et manuscrits modernes in Paris.

EvWM

Fig. 4 | Nietz-
sche's annota-
tions in his copy
of Jean Marie
Guyau's *L'irréli-
gion de l'avenier:
Étude sociolo-
gique* (Paris,
1887), call num-
ber C 268

Oppositional

This artist's book of original drawings by Jörg Kowalski dates from the fall of the Berlin Wall in 1989/1990. It was published in 1991 by Edition Augenweide, a small press based in Bernburg an der Saale founded by Kowalski and fellow artist Ulrich Tarlatt five years earlier. *Cluster* is a work of visual and experimental poetry. The clippings from GDR newspapers from the period September 1989 to April 1990 contain words and phrases that tell of how East German society was being transformed – and its language with it. The text collage is printed on a single web of paper folded to form pages so that readers can either leaf through it like a book or unfold it like a fanfold. 'These changes in the lexical material are barely perceptible to the individual as they are happening', writes Kowalski in the afterword. 'Only the sum of the sequentially arranged word clusters proves, more powerfully than any in-depth analysis, the exemplary changes of those months.'

The quotes relate to the opening of the Hungarian-Austrian border in September 1989, to the demonstrations by GDR opposition figures in October, to the Fall of the Wall in November and to the transformative processes of the ensuing months. The lower-case sequences are lined up without punctuation or spaces, giving rise to some unexpected concatenations, as in November 1989: 'erneuerung des sozialismus ein kunstvoller schwank von amtswegen 1. sekretär entbunden paß- und meldewesen real partei- und staatsdiszplin beschleunigt viel verkehr an grenzpunkten heimat mal von der anderen seite' (lit. 'renewal of socialism an artful farce ex officio first secretary released passports and registration real party and state discipline accelerated heavy traffic at border posts home from a different perspective'). The process of reunification between East and West is reflected in these abrupt juxtapositions of text fragments merging seamlessly.

AB

Jörg Kowalski, Cluster (Halle/Bernburg: Edition
Augenweide, 1991), shelf mark 311731 - C

Jens Henkel gave this artist's book to the Herzogin
Anna Amalia Bibliothek (Duchess Anna Amalia
Library) in 2021.

BEYOND STATE DOCTRINE – UNDERGROUND LITERATURE AND ARTISTS' BOOKS FROM EAST GERMANY

The Herzogin Anna Amalia Bibliothek (Duchess Anna Amalia Library) did not acquire any literature or art that fell outside official East German culture prior to the fall of the Berlin Wall. These days, by contrast, printed matter produced by East German dissidents before and during the upheavals of 1989–1990 is an important field of collecting. As direct articulations of protest and rebellion against official culture, these 'Zweite Kultur' (lit. 'second culture') artists' books and magazines constitute an important, hitherto poorly researched body of material. They contain literary and artistic approaches that attest to both the conscious opposition and non-conformist behaviour of their authors. Official publishers had no control over this 'grey' literature, which more often than not was circulated in the form of handwritten copies, carbon-copy typescripts and photocopies. It was also known as 'Samisdat' after the Russian word for self-publishing.

The Herzogin Anna Amalia Bibliothek is, for example, in possession of a collection of East German Mail Art of the seventies and eighties, which can be read as a precursor of today's net literature. To elude the censors, letters, cards and other objects were sent from one recipient to the next, and each time added to and embellished before being forwarded to the next addressee, thus creating unique works of art and literature. As a medium of both communication and artistic resistance from 1984 onwards, Mail Art in East Germany developed into a nationwide movement. Inevitably, the Stasi soon had it in its crosshairs and in an operation

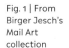

Fig. 1 | From Birger Jesch's Mail Art collection

called simply *'Feind'* (lit. 'enemy') put the Dresden Mail Art group under surveillance. One of that group's exponents, the conceptual artist Birger Jesch (b. 1953) who now lives near Weimar, has since given his Mail Art collection to the library (fig. 1). Another nearby Mail Art centre was Halle, where in 1987 Guillermo Deisler launched an artists' magazine called *Univers*, to which Jörg Kowalski und Ulrich Tarlatt also contributed.

Underground literature was a widespread phenomenon in 1980s East Germany. Galleries became places of literary and artistic exchange, among them the

ACC Galerie (Autonomes Cultur Centrum) in Weimar, founded just a stone's throw away from the library in 1987, and the Galerie Schwamm that opened in 1988. The Weimar-based artists' magazine *Reizwolf* (1988–1990) was published and circulated by the same circle (fig. 2). Amongst the important small-press magazines featuring original texts and graphics from the GDR now to be found in the library are *Entwerter/Oder* (1982 to the present), *UND / USW / USF* (1982–1992), *Mikado* (1983–1987), *Schaden* (1984–1987), *Anschlag* (1984–1989), *Ariadnefabrik* (1986–1990), *Glasnot* (1987–1989), *Liane* (1988–1994), and *Verwendung* (1988–1991).

Some of these alternative networks would later become successful publishers such as the Burgart-Presse in Rudolstadt, all of whose publications, along with parts of its archive, are to be found in the library. Also to be found on its shelves are original artists' books from the immediate aftermath of the Fall of the Wall that perpetuate the tradition of cross-pollinating words and pictures and/or are relevant to the themes of the Klassik Stiftung Weimar. The Herzogin Anna Amalia Bibliothek remains dedicated to the documentation and preservation of East Germany's underground literary scene, whose many testimonials to the peaceful revolution of 1989 are still an important strand of its collecting policy even today.

AB

Fig. 2 | Title page of the artists' magazine *Reizwolf*, no. 1 (Weimar, 1988), shelf mark ZB 2229 (1)

Fragile

The library fire of September 2004 exacted a heavy toll in terms of
both the works that were lost and those countless historical books
that were severely damaged. As it was the second gallery of the
Rokokosaal (Rococo Hall) and the attic floor above it that went up
in flames, the books shelved there were the ones worst affected.
All that is left of them are the '*Aschebücher*' – the charred books
retrieved from the ashes. One such work is the geometry textbook
De lateribus et angulus triangulorum (Of the Sides and Angles of
Triangles), which Nicolaus Copernicus published in 1542 before
ushering in the Copernican turn. While the flames completely
consumed the binding, the book block itself was charred only
around the edges and the paper soiled – in places severely – by a
mixture of soot and rubble. Despite the grave loss of substance,
conservators were able to salvage the fragment by applying a new
process of identification, documentation and restoration, and
have since been able to return it to the shelves in a usable condi-
tion. While the work still bears all the marks of its history as well
as the scars left by the fire, prior to its treatment it was as good as
lost, even though much of the content had in fact been saved. This
volume thus serves as an example of how to make the best of a
bad situation: so important and unique were the damaged books
that the Herzogin Anna Amalia Bibliothek (Duchess Anna Ama-
lia Library) felt justified in embarking on an innovative process of
restoration through which the original written documents might
be preserved.

AH

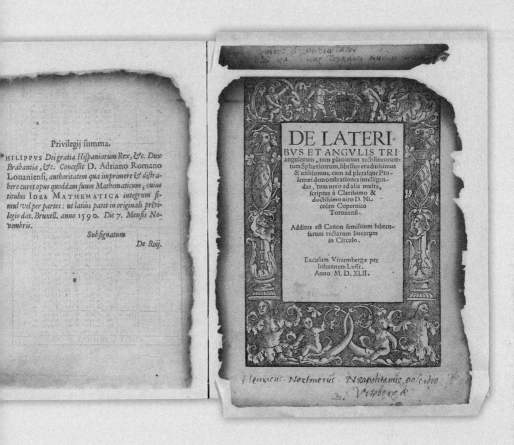

Nicolaus Copernicus, De lateribus et angulis
triangulorum ... (Wittenberg: Hans Lufft, 1542),
damaged in the fire of 2004, restored in 2016,
shelf mark Scha BS 4 A 02255

The treatise belonged to Johannes Heinrich
Nortmerus.

CHARRED BOOKS – FRAGMENTS IN A NEW FORM

On 2 September 2004, defective wiring in the Herzogin Anna Amalia Bibliothek (Duchess Anna Amalia Library) sparked the largest library fire in Germany since the Second World War. The blaze broke out above the Rokokosaal (Rococo Hall), to which the library owes the UNESCO World Heritage status accorded it in 1998. What was lost was not just the historical fabric of the building, but also most of the books kept there, which were destroyed either by the fire itself or the efforts to extinguish it and salvage the lost treasures. The library's holdings were made up of wide-ranging, unparalleled collections of literature dating from the fifteenth to the twentieth century. Once the remaining books had been retrieved and first aid administered, it was time to take stock of the damage: some 50,000 books had been lost and 118,000 damaged to a greater or lesser degree, depending on where in the central section of the building they had been located. Another 28,000 books remained unscathed. The bulk of the damaged volumes has since been restored. By 2017, some 56,000 books soiled with soot, wood preservatives or microbes as well as 37,000 others whose bindings had been damaged either by heat or water had been returned to the shelves.

The books whose charred remains were sifted out of the debris of the second gallery of the Rokokosaal, however, appeared to have been lost irreparably. Some 25,000 salvaged units from that area were set aside in special containers together with other debris, pending the conclusion of the public prosecutor's investigations. In the end, the identifiable fragments were fished out after all, because although the bindings had been destroyed, the book blocks themselves had in many cases survived the fire, despite being

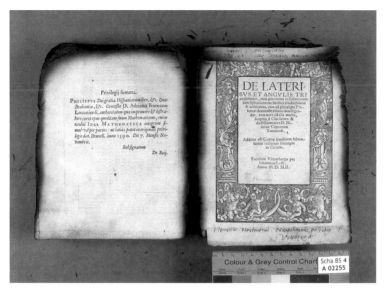

charred or even carbonized around the edges (fig. 1). Soon, these books were being referred to as *Aschebücher* (lit. 'ash books').

Once first aid had been administered, the charred books were packed into separate boxes, with padding, and sent to an interim storage facility for identification, classification and further analysis. Each volume is assigned a number to replace the old shelf mark and the catalogue entry is updated to ensure that it remain searchable. It is during this process that the decision on whether and how to restore each book was taken. Criteria such as the year of publication, any features or qualities unique to that copy or collection and the existence of identical copies all play a role here, as does the conservators' assessment of the damage. More than 6,000 volumes have so far undergone a restoration process tailored to the specific needs of each book. In 2008, the library established a new restoration workshop in Legefeld dedicated to the treatment of the fire-damaged books and papers. By 2028, it will have restored some 1.5 million pages.

Prior to the blaze at the Herzogin Anna Amalia Bibliothek there was no known method for restoring such severely damaged books in such huge numbers. Elements of existing methods for the preservation of written documents were adopted and adapted to make the books usable again. One such adaptation was a new kind of compression box for restoring paper made of stainless-steel mesh, which had the advantage of allowing the damaged paper to

Fig. 2 | Conservation binding to facilitate the use and permanent preservation of the charred book

be handled gently and in large quantities. The restorers proceed by separating the pages and then placing them in the correct order inside the box, interspersed with sheets of an absorbent material to which they cling while being cleaned in a water bath. Before drying, they are then placed in a pulp suspension for paper grafting to repair any holes or tears. Each double page is then stabilised by lining on both sides with wafer-thin Japan paper, pasted on with a very fine adhesive compound. The sheets are then placed between absorbent materials and dried in stacks. While the process relies heavily on technical equipment, it is steered by hand and requires manual intervention. To spare it any mechanical stress, the paper remains sandwiched between synthetic support materials throughout the wetting process. The materials grafted or pasted onto the paper, by contrast, are all purely plant- or mineral-based raw materials. Finally, the book block is reconstructed and furnished with a conservation binding (fig. 2) and a sleeve. In this form, the books can once again be consulted by users of the library (fig. 3). Operated by the Herzogin Anna Amalia Bibliothek in collaboration with Hildesheim University of Applied Sciences and Arts and Vienna University of Natural Resources and Life Sciences, the restoration workshop is an academic teaching workshop in which students in various programmes or engaged in research can receive training and acquire hands-on skills in the mass restoration of paper in the professional context of the preservation of our cultural heritage.

AH

Fig. 3 | The charred books after restoration
shelved in the underground stacks

HISTORY OF THE LIBRARY AT A GLANCE

1547 Defeated by the imperial army at the Battle of Mühlberg, Elector Johann Friedrich I loses his electoral status and with it some of his domains, including the ducal seat of Wittenberg. The Wittenberg library is transferred to the new ducal seat of Weimar.

1549 All but a few hundred of the books in Weimar are transferred to Jena, where they form the basis of what will later become the university library. From his prison cell in Augsburg, Johann Friedrich orders the books still in Weimar to be installed in the Residenzschloss (the Ducal Castle) and inventoried.

1562–1565 The 'Grünes Schloss' (Green Castle) is built as a ducal residence.

1574–1576 The 'Rotes Schloss' (Red Castle) is built to house the Dowager Duchess Susanna of Saxe-Weimar. Today it is part of the Study Centre.

1618 The ducal library is almost completely destroyed by a fire at the Residenzschloss.

1667 When Wilhelm IV dies, his library eventually falls to his four sons so that the books end up in Jena, Marksuhl, Eisenach, and Altenkirchen, while some remain in Weimar. This will be the last of many occasions in the sixteenth and seventeenth centuries when the library has to be split up for inheritance reasons.

1691 The court at Weimar receives 500 books from the now defunct cadet line of Saxe-Jena. This windfall prompts Duke Wilhelm Ernst of Saxe-Weimar to begin systematically augmenting his library, which at the time comprises some 1,500 books.

1701 Two major collections are acquired: the library of Moritz von Lilienheim, councillor to the court of Saxe-Weimar, and that of the Breslau jurist, Balthasar Friedrich von Logau.

1704 The 'Gelbes Schloss' (Yellow Castle) is built to the north of the Rotes Schloss. Originally the residence of the Dowager Duchess Charlotte Dorothea of Saxe-Weimar, it is now part of the Study Centre.

1706 Konrad Samuel Schurzfleisch, a scholar from Wittenberg, is appointed first director of the Herzogliche Bibliothek (Ducal Library).

1708 Upon his death he is succeeded as director by his brother, Heinrich Leonhard Schurzfleisch.

1722 The ducal house expropriates the Schurzfleisch brothers' private library and incorporates it into the Herzogliche Bibliothek, which now numbers 20,000 volumes.

1750 The running of the library is entrusted to the brothers Wilhelm Ernst and Johann Christian Bartholomäi. They regulate its opening hours and lending practices, consolidate its finances and draw up alphabetical and subject catalogues.

1759 A year after her husband's death, Duchess Anna Amalia of Saxe-Weimar-Eisenach becomes regent for her two minor sons, Carl August and Friedrich Ferdinand Constantin.

1760–1766 Anna Amalia has the Grünes Schloss remodelled to house a library designed by Johann Georg Schmid and August Friedrich Straßburger.

1766 Some 30,000 books are transferred from the Residenzschloss to the new Rokokosaal (Rococo Hall).

1775 On reaching his majority, Duke Carl August of Saxe-Weimar-Eisenach takes over the reins of government.

After 1782 Plaster and stone busts by the court sculptor Martin Gottlieb Klauer are installed in the inner oval of the Rokokosaal. The subjects portrayed are Anna Amalia and Carl August, Herder, Wieland, and Goethe, the scholar of ancient languages Jean-Baptiste Gaspard d'Ansse de Villoison and the writer Guillaume-Thomas François Raynal.

1797 Carl August entrusts his privy councillors Johann Wolfgang Goethe and Christian Gottlob Voigt with the oversight of the library. They introduce a modern administration, new rules governing its use and a systematic acquisitions policy. The newly appointed librarian, Christian August Vulpius, is instrumental in making the books accessible to interested readers and scholars.

C. 1800 Weimar by now has a population of 7,500, of whom 475 are registered readers at the library.

1803–1805 At Goethe's instigation and under his supervision an extension to house the Kunstkabinett and stacks is built onto the south side of the Grünes Schloss.

1805 Ferdinand Jagemann paints the life-size portrait of Carl August that will henceforth be a focal point of the Rokokosaal.

1807 Anna Amalia dies aged sixty-seven. She leaves behind one of the largest private libraries of any German princess of the eighteenth century. Its 5,000 volumes are absorbed into the Herzogliche Bibliothek.

1815 The Duchy of Saxe-Weimar-Eisenach becomes a Grand Duchy, whereupon the library becomes the Großherzogliche Bibliothek (Grand Ducal Library).

1820 Two gatehouses designed by the architect Clemens Wenzeslaus Coudray are erected to the east of the Rotes Schloss. Today they are part of the Study Centre.

1823–1825 Carl August has a tower that was formerly part of the city's defences converted into a Bücherturm (Book Tower). Here he will house his Militärbibliothek (Military Library) as well as his collection of coins, medals and globes.

1826 'Friedrich Schiller's skull' is ceremoniously interred in the pedestal of the marble bust of the poet sculpted by Johann Heinrich Dannecker. A year later it will be properly buried in the ducal vault together with what are purportedly his other mortal remains.

1831 The monumental marble bust of Goethe by Pierre-Jean David d'Angers is unveiled to great fanfare in the Rokokosaal in honour of the poet's eighty-second birthday.

1832 Johann Wolfgang Goethe dies aged eighty-two. Under his oversight, which ended only with his death, the collection has grown to 80,000 volumes.

1840 Johann Joseph Schmeller's painting of *Goethe in His Study Dictating to His Scribe John* (1834) is gifted to the library by Duchess Maria Pavlovna.

1834–1838 Weimar's old guardhouse is replaced by a new one, the Hauptwache, built from plans by the architect Coudray. It adjoins the Gelbes Schloss to the east and like that building is now part of the Study Centre.

1844–1849 The Grünes Schloss is again enlarged by a second extension built onto its north side after plans by Coudray. This 'Coudray Extension' will henceforth house the library administration.

1875 The library's holdings have by now risen to 170,000 volumes.

1918–20 Following the November Revolution, the Großherzogliche Bibliothek passes into the hands of the new 'Land' of Thuringia, and is renamed the Thüringische Landesbibliothek Weimar (Thuringian State Library Weimar). The collection is growing steadily and now numbers 400,000 volumes.

1933–1945 During the Nazi period, the Landesbibliothek expropriates books from Social Democrat-run local libraries, workers' libraries and the private libraries of Jewish families.

1937 A modern reading room is installed on the library's ground floor.

1942–1943 A large part of the collection is taken into safekeeping to protect it from war damage.

1945–1955 Nearly 10,000 volumes identified as 'National Socialist writings' are removed from its shelves. Books that have fallen to the state as a result of East Germany's land reforms and expropriations are incorporated into the collection. The library will continue accessioning such books for many years to come.

1951 The work of turning the library into a general academic library begins. It also becomes the region's principal lending library and supplier of literature.

1953–1982 It receives copies of all the works published by publishing houses in Erfurt, Gera and Suhl.

1954 The Nationale Forschungs- und Gedenkstätten der klassischen deutschen Literatur (National Research and Memorial Sites of Classical German Literature), a precursor of the Klassik Stiftung Weimar, founded in 1953, are given their own library. Called the Zentralbibliothek der deutschen Klassik (Central Library of the German Classics) it will henceforth perform the services of a library specialised in literary scholarship.

1960 One of its projects is the *Internationale Bibliographie zur deutschen Klassik 1750–1850,* which today lives on in the digital resource *Klassik online.*

1969 The Thüringische Landesbibliothek is integrated into the Nationale Forschungs- und Gedenkstätten and the two libraries merged as the Zentralbibliothek der deutschen Klassik. Its focus is at the same time narrowed and some of the collections (some 20,000 volumes) deaccessioned and sold on the international market

through the Zentralantiquariat in Leipzig. The library still boasts some 750,000 volumes, most of them kept in stacks in several different locations.

1991 After German reunification, and to mark its tricentennial in 1991, the library is renamed the Herzogin Anna Amalia Bibliothek and is given a new profile as a scholarly library specialised in the period 1750 to 1850.

1998 The library building together with other sites of relevance to Weimar Classicism are declared a UNESCO World Heritage site. The collection has by now grown to 910,000 volumes.

2000 The historical ensemble of Hauptwache, Rotes Schloss and Gelbes Schloss is selected as additional space into which the library can expand, and there are plans to install modern stacks underneath the Platz der Demokratie.

2001 Work on the future Study Centre begins under the supervision of the architects, Hilde Barz-Malfatti and Karl-Heinz Schmitz. A new Bücherkubus (Book Cube) is erected in the courtyard of this historical ensemble.

2003 The Gesellschaft Anna Amalia Bibliothek e. V. is founded as a society of friends of the Herzogin Anna Amalia Bibliothek with Annette Seemann as its first chairperson.

2.9.2004 A huge fire damages large parts of the historical library building, including the famous Rokokosaal and the collections kept there.

since 2004 118,000 volumes damaged by fire and/or water are salvaged and one by one restored. Among them are 25,000 charred books retrieved from the ashes.

2005 The Study Centre is opened.

24.10.2007 The repaired and restored historical library building is reopened on Duchess Anna Amalia's birthday. The architect responsible for the restoration of the building (2004–2007) is Walther Grunwald.

2008 A special workshop for the restoration of fire-damaged documents opens in Weimar-Legefeld. It is the only one of its kind in Germany. This is where the charred books are restored.

2010–2022 All the acquisitions of the years 1933 to 1945 are systematically reviewed in order to identify any that were expropriated from persons persecuted by the Nazis and if possible restore them to their rightful owners. The online catalogue has flagged items that were looted by the Nazis since 2005.

2015 The Weimar Luther Bible of 1534 and Luther's tract, *Eynn Sermon von dem Ablas vnnd gnade* of 1518 are added to the UNESCO list of World Heritage documents.

2018 The board of trustees of the Klassik Stiftung Weimar ratifies the Herzogin Anna Amalia Bibliothek's Agenda 2020plus, in which its stated aim is to become a major archive and scholarly library for European literature and the history of European arts and culture with a special focus on the period 1750 to 1850.

LITERATURE

Costadura, Edoardo, and Eller-brock, Karl Philipp (eds.), Dante, ein offenes Buch. Berlin/Munich, 2015.

Dohe, Sebastian, and Spinner, Veronika, Cranachs Bilderfluten. Weimar, 2022.

Gehren, Miriam von, Die Herzogin Anna Amalia Bibliothek in Weimar: Zur Baugeschichte im Zeitalter der Aufklärung. Cologne/Weimar/Vienna, 2013.

Grunwald, Walther, Knoche, Michael, and Seemann, Hellmut (eds.), Die Herzogin Anna Amalia Bibliothek: Nach dem Brand in neuem Glanz, with photographs by Manfred Hamm. Berlin, 2007.

Hageböck, Matthias, Kleinbub, Claudia, Metzger, Wolfgang, and Reichherzer, Isabelle (eds.), Kunst des Bucheinbandes: Historische und moderne Einbände der Herzogin Anna Amalia Bibliothek. Berlin, 2008.

'Duchess Anna Amalia Library. Historical Library Building', in Cultural Monuments in Thuringia, (ed.) Thuringian State Office for Monument Preservation and Archeology, vol. 41: City of Weimar: Old Town, Rainer Müller (ed.), Altenburg, 2009, pp. 310–315.

Hirsching, Friedrich Karl Gottlob, Versuch einer Beschreibung sehenswürdiger Bibliotheken Teutschlands nach alphabetischer Ordnung der Städte, vol. 1. Erlangen, 1786; vol. 4. Erlangen, 1791.

Ichmann, Achim, Das Rokoko in der Herzogin Anna Amalia Bibliothek. Wiesbaden, 2022.

Kleinbub, Claudia, and Mangei, Johannes (eds.), Vivat! Huldigungsschriften des 17. bis 19. Jahrhunderts am Weimarer Hof. Göttingen, 2010.

Kleinbub, Claudia, Lorenz, Katja, and Mangei, Johannes (eds.), "Es nimmt der Augenblick, was Jahre geben", Vom Wiederaufbau der Büchersammlung der Herzogin Anna Amalia Bibliothek. Göttingen, 2007.

Knebel, Kristin, 'Ein Schlossbau im europäischen Kontext. The Plans of the Weimar Wilhelmsburg by Johann David Weidner from 1750'. in Hellmut Th. Seemann (ed.), Europa in Weimar: Visions of a Continent. Jahrbuch der Klassik Stiftung Weimar, Göttingen, 2008, pp. 105–135.

Knoche, Michael, Die Herzogin Anna Amalia Bibliothek: Ein Portrait. 2nd exp. & rev. ed. Berlin, 2016.

Knoche, Michael, Auf dem Weg zur Forschungsbibliothek: Studien aus der Herzogin Anna Amalia Bibliothek. Frankfurt am Main, 2016.

Knoche, Michael (ed.), Herzogin Anna Amalia Bibliothek: Kulturgeschichte einer Sammlung. Weimar, 2013. After the 1st ed. by Hanser, 1999.

Knoche, Michael, Die Bibliothek brennt: Ein Bericht aus Weimar. 4th corr. & exp. ed. Göttingen, 2013.

Knoche, Michael (ed.), Reise in die Bücherwelt: Drucke der Herzogin Anna Amalia Bibliothek aus sieben Jahrhunderten. Cologne/Weimar/Vienna, 2011.

Knoche, Michael (ed.), Die Herzogin Anna Amalia Bibliothek in Weimar: Das Studienzentrum, with photographs by Klaus Bach and Ulrich Schwarz. Berlin, 2006.

Kratzsch, Konrad, Von Büchern und Menschen: Arbeiten aus drei Jahrzehnten als Bibliothekar an der Herzogin Anna Amalia Bibliothek in Weimar. Hamburg, 2017.

Kratzsch, Konrad (ed.), Kostbarkeiten der Herzogin Anna Amalia Bibliothek Weimar. 3rd rev. ed. Leipzig, 2004.

Kratzsch, Konrad, and Seifert, Siegfried, Historische Bestände der Herzogin Anna Amalia Bibliothek zu Weimar: Beiträge zu ihrer Geschichte und Erschließung. Munich et al., 1992.

Laube, Reinhard, 'Feuer aus? Weimars "Aschebücher" und die Resilienz der Überlieferung'. In: Zeitschrift für Ideengeschichte 16, no. 1 (2022), pp. 101–114.

Laube, Reinhard, 'Das Wissen der Sammlungen: Die Zukunft der Archiv- und Forschungsbibliothek'. In: Zeitschrift für Bibliothekswesen und Bibliographie 67, no. 1 (2020), pp. 6–14.

Laube, Reinhard (ed.), Brandbücher | Aschebücher: Perspektiven auf Hannes Möllers künstlerische Intervention in der Herzogin Anna Amalia Bibliothek. Weimar, 2020.

Laube, Reinhard, 'Agenda 2020 der Archiv- und Forschungsbibliothek'. In: SupraLibros, no. 24 (2019), pp. 23–26.

Raffel, Eva, Galilei, Goethe und Co. Freundschaftsbücher der Herzogin Anna Amalia Bibliothek. Immerwährender Kalender. Unterhaching, 2012.

Raffel, Eva (ed.), Welt der Wiegendrucke: Die ersten gedruckten Bücher der Herzogin Anna Amalia Bibliothek. Leipzig, 2007.

Schöll, Adolf, Weimar's Merkwürdigkeiten einst und jetzt: Ein Führer für Fremde und Einheimische. Mit einem Plan von Weimar. Weimar, 1857.

Seemann, Annette, and Bürger, Thomas (eds.), 325 Jahre Herzogin Anna Amalia Bibliothek Weimar. supplement to SupraLibros. Weimar, 2016.

Seemann, Annette, Die Geschichte der Herzogin Anna Amalia Bibliothek. Frankfurt am Main/Leipzig, 2007.

SupraLibros. 'Mitteilungen der Gesellschaft Anna Amalia Bibliothek e. V'. Edited by the Gesellschaft Anna Amalia Bibliothek e. V. and der Herzogin Anna Amalia Bibliothek. Weimar, 2007–ongoing.

Weber, Jürgen, and Hähner, Ulrike (eds.), Restaurieren nach dem Brand. Die Rettung der Bücher der Herzogin Anna Amalia Bibliothek. Petersberg, 2014.

Zimmermann, Hans (ed.), 100 Jahre Cranach-Presse: Buchkunst aus Weimar. Berlin, 2013.

The QR codes provided for the key objects lead to additional digital information.

Further details on the literature used in the texts can be found here:

Herzogin Anna Amalia Bibliothek
(Duchess Anna Amalia Library)
Edited by Reinhard Laube

Concept: Reinhard Laube,
 Veronika Spinner
Editing: Angela Jahn, Anja
 Jungbluth, Veronika Spinner
Image research and digitisation:
 Hannes Bertram, Susanne
 Marschall, Andreas Schlüter
Translation: Bronwen Saunders
Copy-editing: Aaron Bogart

Authors:
Arno Barnert (AB)
Annett Carius-Kiehne (ACK)
Andreas Christoph (AC)
Alexandra Hack (AH)
Rüdiger Haufe (RH)
Stefan Höppner (SH)
Reinhard Laube (RL)
Katja Lorenz (KL)
Christian Märkl (CM)
Christoph Schmälzle (ChS)
Veronika Spinner (VS)
Claudia Streim (CS)
Ulrike Trenkmann (UT)
Jürgen Weber (JW)
Erdmann von Wilamowitz-
 Moellendorff (EvWM)

Cover design, layout and typeset-
 ting: Deutscher Kunstverlag,
 Berlin/Munich
Printing and binding: Grafisches
 Centrum Cuno, Calbe

The German National Library lists
this publication in the German
National Bibliography; detailed
bibliographic data is available at
http://dnb.dnb.de.

© 2022 Deutscher Kunstverlag
GmbH Berlin Munich
Lützowstrasse 33
10785 Berlin

A company of Walter de Gruyter
GmbH Berlin Boston
www.deutscherkunstverlag.de
www.degruyter.com
ISBN 978-3-422-98718-0

Series 'In Focus'
Published by the Klassik Stiftung
Weimar

Concept: Gerrit Brüning
Realisation: Daniel Clemens

The Klassik Stiftung Weimar is
funded by the German Federal
Government Commissioner for
Culture and Media on the basis
of a resolution of the German
Bundestag as well as the Free
State of Thuringia and the City
of Weimar

Die Beauftragte der Bundesregierung
für Kultur und Medien

Freistaat
Thüringen Staatskanzlei

weimar
Kulturstadt Europas